A–Z

OF

CHESTER

Places - People - History

Mike Royden

AMBERLEY

In memory of my parents Bill and Hazel Royden, whose
love of Chester was clear to see (taken 1952–53)

First published 2018

Amberley Publishing
The Hill, Stroud, Gloucestershire, GL5 4EP
www.amberley-books.com

Copyright © Mike Royden, 2018

The right of Mike Royden to be identified as
the Author of this work has been asserted in
accordance with the Copyrights, Designs and
Patents Act 1988.

ISBN 978 1 4456 7454 4 (print)
ISBN 978 1 4456 7455 1 (ebook)

British Library Cataloguing in Publication Data.
A catalogue record for this book is available
from the British Library.

Origination by Amberley Publishing.
Printed in Great Britain.

Contents

Introduction

When that famous leader of the Judean People's Front asked 'What have the Romans ever done for us?', in my case they named the occupying force of Chester XX Legion, thereby bailing me out for the letter X in this volume. Of course, they did much more, and there is still a great deal left to see in this wonderful historic city. Yet the Roman period is only part of what there is to learn about Chester. The city didn't die after their demise, only to re-emerge as a popular tourist destination from the nineteenth century onwards. There is a wealth of history in between, with an impressive array of preserved buildings, many with a unique story to tell. In preparing this book I have also tried to avoid featuring many of the buildings covered in Amberley's volume *Chester in 50 Buildings* by Paul Hurley (2017), although there may be a brief overlap here and there.

Although I grew up in Liverpool, visits to Chester were a regular treat, and now that I have lived for several years in a village just south of Chester, I never tire of walking through the streets. There is always something new to discover, especially when I make a conscious effort to look up at the architecture instead of just hurrying through, head down, on whatever mission I am on. In fact, my links here with the Royden family go back a long way as my direct ancestors lived here in the 1600s, and all those with that surname in the north-west are almost certainly their descendants (I've done the tree). It does feel like home.

Use this volume as an introduction, especially if you haven't visited the city before. The entries are short, governed by the format, but further reading has been included should you wish to delve deeper. If you haven't visited Chester, its time it was on your bucket list.

Almshouses

Pensions may be a statutory requirement today, with the retirement age for a state pension laid down in law, but prior to state provision citizens had to keep working well into old age to support themselves. There was the option of care from their family or friends of course, but for the truly desperate there was the workhouse. An alternative for a lucky few was the almshouse. Sometimes known as a poorhouse, almshouses were charity homes usually for the elderly who could no longer work and pay rent. They were sometimes provided for those with particular former occupations or their widows, and often had their foundation in the church system, or a charity bequest from rich individuals, managed by trustees.

There have been numerous almshouses in Chester's history although most are long gone.

ALMS HOUSES

Besides other houses mentioned, there are the following. In Little St. John's Street, four, built by Mrs Deighton Salmon in 1738, with a small endowment. Ten almshouses in Pepper Street, in St Michael's Parish, called Jones's almshouses, for six poor men and four poor women, decayed housekeepers of good reputation, with good endowment. Six alms houses in Common Hall Lane, with an endowment of one pound six shillings and eight pence each. Six almshouses in St. Olave's parish, with an annual endowment of twenty shillings each. Four almshouses in St. Martins in the Fields, with an annual endowment of twenty shillings each. Besides these, Alderman Thomas Wilcocke left an estate in Wirral, between the parishes of St. John, St. Bridget, and the town of Neston, the profits of which were to be distributed annually amongst those decayed housekeepers, who have never troubled the parish, and conducted themselves soberly and piously; deducting small sums for a sermon, etc. and reading the will annually, at the altar of each church so named, when the money is then distributed to the objects attending for that purpose.

John Broster, *A Walk Around the Walls of Chester* (1810), pp.76−77

An early medieval foundation was St John's Hospital just outside the Northgate in the 1190s, which provided for the maintenance of thirteen poor men, who were to receive daily throughout the year, 'a quartern loaf of good bread, a dish of pottage, and a certain pittance of fish or flesh as the day may be, and half a gallon of competent ale'.

The hospital was destroyed during the Civil War siege (*see* Siege of Chester), but the site was rebuilt as the Bluecoat School in 1717, with thirteen almshouses added to the rear. In 1845, they were replaced with fourteen almshouses built for the trustees of the Hospital of St John Baptist, and described as 'forming three sides of a quadrangle, each containing a sitting-room, bed-room and scullery under the same roof, and inhabited by thirteen poor and aged people, male or female, each receiving ten shillings per week, together with gas, a certain allowance of coals during the year and medical attendance; one of the inmates acts as matron and nurse, for which she receives 3s. 10d. per week additional.' In 1976 the hospital, still supporting thirteen almshouses, was absorbed by the Chester Municipal Almshouse Charity, and remains in use today. In April 2006 a brand new almshouse – the first to be built since the mid-nineteenth century – was opened in the square behind the Bluecoat where the estate now consists of sixteen one-bedroom houses set around the courtyard.

Also still in use, but now in private ownership, are 'The Nine Houses', although today only six remain. Situated in Park Street, just below Newgate, where there is a fine view

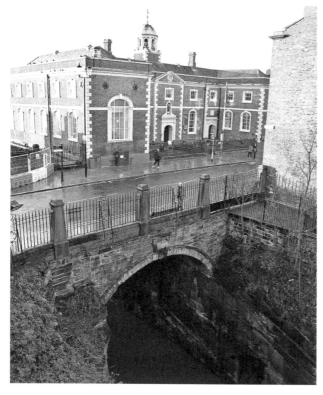

The Bluecoat building viewed from the city walls, built on the site of St John's Hospital. (Photo: Lewis Royden)

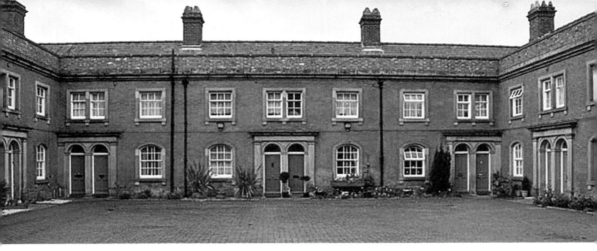

St John's Almshouses to the rear of the Bluecoat building.

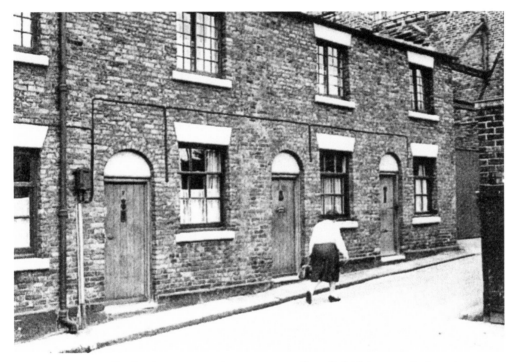

Green and Wardell's almshouses, Crook Street, 1965 (demolished in 1973 during city centre redevelopment).

from the city walls, they are the only surviving pre-nineteenth-century almshouses in Chester. Built around 1650 as part of the post-Civil War reconstruction (especially as they faced the wall breach of 1645 – *see* Siege of Chester), they were in such dilapidated state and in danger of collapse that campaigns by the Chester Civic Trust and the Chester Archaeological Society to preserve them resulted in their renovation in 1968–69.

The parish boundary marker on the façade refers to the parishes of St Michael and St Olave.

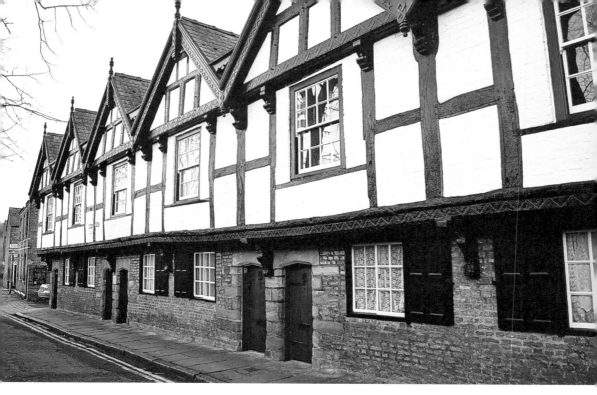

Above: 'Nine houses.' (Photo: Lewis Royden)

Left: 'Nine houses' showing parish boundary markers. (Photo: Lewis Royden)

Anchorite Cell – The Hermitage, a Fourteenth-century Monk's Retreat

On a sandstone outcrop facing The Groves, just a few yards from the suspension bridge, stands a curious building known as the Anchorite Cell. Built in the mid-fourteenth century and with a name derived from the Greek to withdraw, it provided accommodation for a monk or friar wishing to spend time away from society in spiritual

contemplation. The 'mother house' for the cell was the nearby St John the Baptist Abbey. During the medieval period there were over 600 such cells to be found across the country – with at least three in Chester alone. The twelfth-century chronicler Gerald of Wales, a noted spinner of tales, gave the site legendary status when he recorded,

> Harolde had many woundes, and lost hys left eye wyth the strooke of an arrowe, and was overcome; and escaped to the countrye of Chester, and lived holylie, as men troweth, an Anker's life, in Sayne Jame's cell, fast by Saynte John's church, and made a good end, as yt was knowen by hys last confession.

Yes, Gerald really did believe this, or at least an earlier cell, was the final home of the last Saxon king Harold II after he escaped alive from the Battle of Hastings nursing a sore eye.

Constructed in coursed sandstone with a grey slate roof, the building has two storeys with the entrance on the north side. To the right of the porch is a distinctive two-light mullioned casement window, with a triple lancet window above. The upper floor also contains a three-light mullioned window with more lancet windows on the south side.

In the years following the Reformation, it came into private hands and, during a conversion into a house in the late nineteenth century, the porch of St Martin's Church that was undergoing demolition was reinstalled as the north entrance to the cell by 1897. In the early 1970s the building was refurbished as a cottage and is now Grade II listed.

Anchorite cell. (Photo: Lewis Royden)

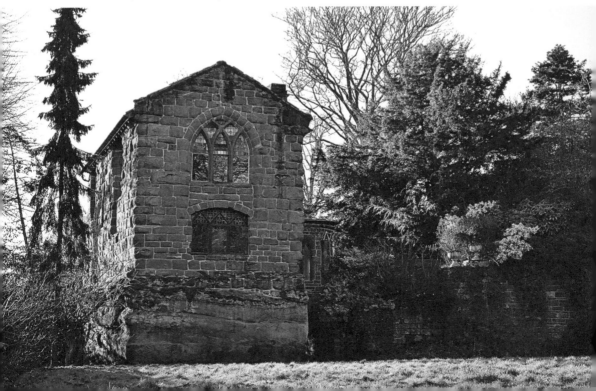

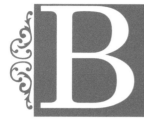

Bishop's Palace, Little St John's Street, The Groves

The Bishop's Palace was built for Samuel Peploe, Bishop of Chester, with original work commencing in the mid-eighteenth century, probably before 1745. It sits on an elevated position on The Groves, just below the Abbey of St John, overlooking the river. Constructed in red brick with a hipped roof, the building was completed in 1751, but was substantially expanded in the later eighteenth century, with further alterations in the nineteenth, although the exterior is largely unchanged from its original construction apart from the main door. Bishop Peploe, who had been in office since 1726, had little time to enjoy his new residence, passing away on 21 February 1752, and buried in Chester Cathedral where his memorial was placed on the north wall of the building. From 1865 until the 1920s it was the official residence of the bishops

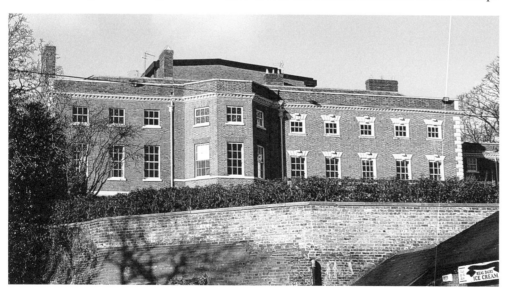

The Old Bishop's Palace. (Photo: Lewis Royden)

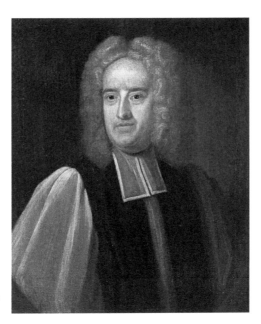

Samuel Peploe (1667–1752), Bishop of Chester.
(Unknown artist)

of Chester, before it underwent conversion as a YMCA hostel, a role that continued until the 1980s. The palace was then subdivided into commercial offices, although it still retained interior features of interest, such as original six panelled doors and the open-well six-flight staircase. The large boardroom on the first floor still retains its eighteenth-century plasterwork and decorated ceiling.

The eighteenth-century Grade II-listed Georgian mansion was acquired by Exclusive Events Venues in 2017, and after redevelopment relaunched the building as an exclusive weddings and events venue the following year.

Brassey, Thomas – World-famous Railway Pioneer

Consider this son of a Cheshire yeoman farmer, growing up in the tiny village of Buerton - 39 souls and no school, when Thomas was born in 1805 - who was to become the biggest contractor in the world, for well over two decades employing on average some 80,000 men at any time at work in a score of countries on any of four continents, altering decisively the social history of the human race, and notwithstanding many a setback leaving one of the largest English fortunes of the century. Cavour, architect of Italian unity (for which he acknowledged the contribution of Brassey's railways), called him 'one of the most remarkable men I know... clear-headed, cautious, yet very enterprising, and fulfilling his engagements faithfully.'

Tom Stacey, *Thomas Brassey: The Greatest Railway Builder in the World* (2005)

So wrote Thomas Brassey's great-great grandson in a short biography of his ancestor.

When Thomas Brassey died in 1870, he was one of the wealthiest of the self-made Victorians, worth well over £5 million. His achievements were quite simply staggering and have affected countless lives across the globe. A great percentage of railways built around the world during the nineteenth century were down to him, and estimated to be around one in every twenty miles by the time of his death.

Yet, as alluded to by Stacey, his start in life was relatively humble, although as the son of a prosperous yeoman farmer he was still in a more privileged position than the local labourers employed on the family farm, as witnessed by him being sent to the King's School in Chester at the age of twelve. His home was Manor Farm in Buerton, a hamlet within the parish of Aldford, around six miles to the south of Chester, where the Brassey family, who farmed in Cheshire for centuries, had moved to from Malpas in 1663.

On leaving the King's School he was apprenticed to William Lawton, a land surveyor and agent, where he assisted the road survey of the Shrewsbury to Holyhead Road (following the old Watling Street, now the A5).

His first construction was the rather modest Saughall Massie Bridge and adjacent watering hole in 1829, after being taken into partnership with Lawton when he turned twenty-one. A plaque and information board now mark the historical significance of the site.

By now they were operating out of Birkenhead, then little more than a village, giving them scope to expand. They acquired local sand and stone quarries and constructed brickworks and limekilns enabling their business to prosper further, supplying materials for the rapidly expanding towns either side of the river. One of their clients was George Stephenson, who needed stone for his Sankey Viaduct as part of his project to build the first fully operational railway in the world from Liverpool to Manchester. Confident his new venture would be a success and would soon expand, he encouraged Brassey to become involved in railways as soon as possible. His first venture was the Penkridge Viaduct, plus 10 miles of track on the Stafford to Wolverhampton line, which opened in 1837, kick-starting his successful career as a railway contractor in this country, before expanding to France and further afield.

Locally, he was responsible for the Chester to Crewe line with Robert Stephenson as engineer, as well as the main line Chester station, completed in 1848. Other local works included the New Chester Road in Bromborough (1834), Birkenhead Docks (1850), the Dee Reclamation Works (1865), stonework for the Runcorn Bridge (1868), Cefn Mawr Viaduct (1848), the Chester railways to Birkenhead (1840), Holyhead (1850), and Shrewsbury, plus the Chirk Viaduct (1859).

Thomas Brassey died from a brain haemorrhage on 8 December 1870 in the Victoria Hotel, St Leonards, while he was living in Sussex.

In Chester memorials to Brassey are rather modest. He is remembered on a plaque in Chester station, while his sons placed a bust in St Erasmus' Chapel in Chester Cathedral. There is also a bust in the Grosvenor Museum, while his name has been given to Brassey Street and Thomas Brassey Court (off Lightfoot Street).

Yet considering his achievements, which surely eclipse those of Stephenson and Brunel, who are appropriately commemorated elsewhere, a more fitting memorial for this world-famous son of Chester is long overdue. The project undertaken by the Chester Civic Trust and the Thomas Brassey Society to erect a bronze life-size statue of Brassey outside Chester station deserves to succeed.

Above: Brassey's first commission: the modest Saughall Massie Bridge.

Right: Thomas Brassey, drawn by Frederick Piercy (1830–91).

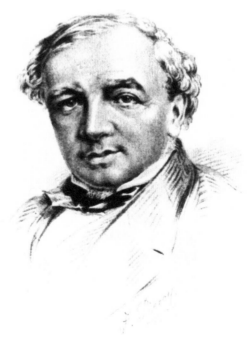

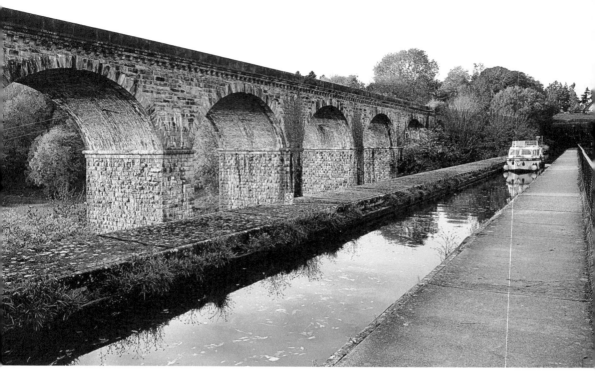

Brassey's viaduct at Chirk, alongside Telford's earlier aqueduct. (Photo: Lewis Royden)

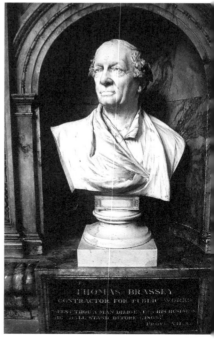

Above left: Brassey plaque, Chester station. (Photo: Lewis Royden)

Above right: Brassey bust, St Erasmus' Chapel, Chester Cathedral. (Photo: Lewis Royden)

Cheshire, Leonard, VC – War Hero and Philanthropist

Group Captain Geoffrey Leonard Cheshire, Baron Cheshire, VC, OM, DSO and Two Bars, DFC, was one of the most highly decorated servicemen of the Second World War, and later became further recognised as a philanthropist.

The Cheshire family had long been established in the county of their name, having lived in the Northwich area from at least the late 1700s, with several of Leonard's family working in courts of law including his father George Chevalier Cheshire, who lectured in law at Exeter College, Oxford. His career was interrupted by war service when he returned home to serve with the 2/6 Battalion Cheshire Regiment and the Royal Flying Corps. He married on 6 February 1915, and he and his wife were living in Hoole when Leonard was born on 7 September 1917. The family home in Hoole Road on the corner of Westminster Road, now a small hotel, bears a blue plaque on the wall to mark the event.

At the end of the war, the family returned to Oxford, where Leonard's brother Christopher was born later that year. George Cheshire had taken a post at All Souls in Oxford, where he would continue to have a distinguished academic career.

Leonard was also educated at Merton College, Oxford, and graduated, like his father, with a degree in jurisprudence in 1939. Before any thought of continuing the family tradition, war broke out and he joined the Royal Air Force (he had already been a member of the University Squadron since 1937). By March 1943, at the age of twenty-five, he became the youngest group captain in the RAF. In 1944, he was awarded the Victoria Cross after completing 102 bombing missions while displaying the courage and determination of an exceptional leader over four years of fighting.

Concerned with the rehabilitation of servicemen who had suffered injuries during the war, he became determined to set up a facility to help them recover and lead as normal life as possible. He founded a residential home for disabled ex-servicemen in 1948 at Le Court, a large country house near Liss in Hampshire. By 1955 the charity, now known as the Cheshire Foundation Homes for the Sick, were running six Cheshire homes in Britain. The first overseas Cheshire Home was established in

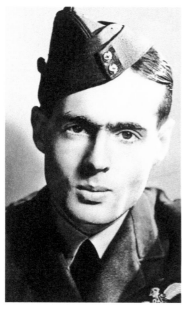

Left: Group Captain Geoffrey Leonard Cheshire, Baron Cheshire, VC, OM, DSO and Two Bars, DFC.

Below: Leonard's birthplace in Hoole Road, Chester. (Photo: Lewis Royden)

Mumbai, India, in 1956. By 1992 there were 270 homes in forty-nine countries. Today the charity is known as Leonard Cheshire Disability.

In recognition of his charity work he was created a life peer in 1991. Leonard Cheshire died of motor neurone disease aged seventy-four on 31 July 1992. Later that year the Queen paid tribute to him in her Christmas message.

Craig, Daniel – an Actor Who Doesn't Care if Its Shaken or Stirred

Now one of the world's biggest movie stars thanks to his role as James Bond, Daniel Craig was born in No. 41 Liverpool Road, Chester, on 2 March 1968 to parents Tim and Olivia (her parents had once managed The Deva Hotel in Watergate Street, now called Amber Lounge). Tim became the landlord of the Ring O'Bells pub in Frodsham, where Daniel attended the village primary school. After his parents split up in 1972, Daniel, together with sister Lea, moved to Liverpool with their mother, where Olivia was to study and qualify as an art teacher. Shortly afterwards, they moved to Hoylake where Daniel attended Hilbre High School, followed by a short period at Calday Grange Sixth Form, before being accepted at the National Youth Theatre and leaving for London at the age of sixteen. After a number of auditions, he was later accepted at the Guildhall School of Music and Drama at the Barbican, where he graduated in 1991.

The following year he made his big screen debut in the drama *The Power of One* (1992), but it was his early break-through role as Georgie in the TV drama *Our Friends in the North* that garnered many plaudits, and raised his profile in the eyes of the British public. He continued to work regularly both in TV and film, and his casting as the sixth Bond in 2005 saw him nominated for a BAFTA for *Casino Royale* (2006). He reprised the role in *Quantum of Solace* (2008), *Skyfall* (2012) and *Spectre* (2015) – with more Bond films to come – while also playing lead roles in several other successful films such as *Cowboys and Aliens* and *The Girl with the Dragon Tattoo* (2011), as well as starring on the Broadway stage with his wife Rachel Weisz in *Betrayal* in 2013.

When work schedules allow, he can frequently be seen at Anfield, while his father Tim and his second wife Kirsty still maintain their Chester ties, where they currently run a staff recruitment company.

Oh, and his Martini? Thankfully we saw a reworking of the line in *Casino Royale* that was first spoken by Bond in *Goldfinger* in 1964 (and even earlier in Fleming's book *Dr No* in 1958). Responding to a bartender asking him if he wanted his Martini 'shaken or stirred', right after he had just lost millions of dollars in a poker game, he responded, 'Do I look like I give a damn?' You can take the boy out of Chester...

Dee Railway Bridge Disaster

The Dee Railway Bridge, to the west of the Roodee, designed by Robert Stephenson and completed in November 1846, has the dubious honour of being the site of first railway bridge disaster in the country, as a result of a catastrophic failure of one of its three 98-foot cast-iron spans, as a train carrying around twenty-two passengers was completing its crossing.

On 24 May 1847, as the Chester to Ruabon local train was slowly making its way to the opposite bank, the driver felt the rails giving way as he was almost on the south side. The carriages (one first class, two second and a luggage van), derailed, uncoupled and began to crash into the river, taking part of the track and bridge span with it. He immediately drew more steam and on passing the end of the bridge the tender came away too throwing the stoker to his death. Clayton, the driver, who was unhurt, pressed on to the next points where he raised the alarm, then on to Saltney station, where he brought back several workmen to help as he reversed the train and recrossed the points to the opposite track. Incredibly, he was able to steam back over the bridge on the opposite undamaged track and continue on to Chester station, where he raised the alarm there.

By now the first-class carriage was lying on the rocky bankside just in the water on the south side of the river, while the two second-class carriages and the brake van were lying

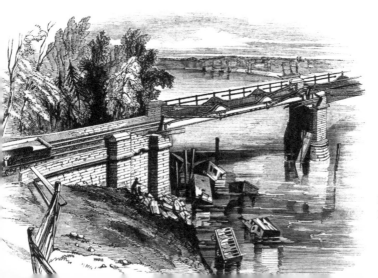

Engraving of the Dee Railway
Bridge Disaster, 24 May 1847.

partly submerged. One of the second-class passengers, finding himself under water in an upside-down carriage, was able to get through the window and swim to safety. Several passengers were not so lucky: three were killed, as well as the train guard, bringing the death total to five, with nine serious injuries. Three bodies were taken to the nearby workhouse next to the railway on the Chester side of the bridge, while the other fatalities, the injured, serious and otherwise, were carried to the Chester Infirmary (*see* Infirmary).

In the local railway inquiry that followed, it was found that the cast-iron design was flawed and Robert Stephenson was accused of negligence. It was a hard lesson learned by Stephenson, who took some convincing before he abandoned the method and rebuilt the Dee Bridge, and subsequent structures on the Chester to Holyhead line, in wrought iron, thereby going some way to recover his reputation.

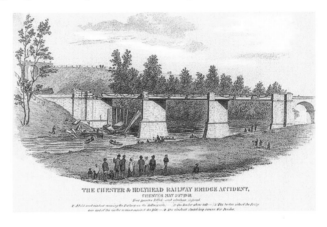

THE CHESTER & HOLYHEAD RAILWAY BRIDGE ACCIDENT,
CHESTER MAY 24TH 1847.

Antique print, 1847.

APPALLING RAILWAY ACCIDENT.

A PASSENGER TRAIN AND ALL THE PAS SENGERS LOST IN THE RIVER DEE.

At a late hour last night intelligence reached us that a most melancholy and appalling accident had occurred at Chester, on the Chester and Shrewsbury Line of Railway. At Chester the railway is carried along the margin of the race-course upon arches, and crosses the river Dee by a suspension bridge. From what we could learn, it appears that as the Wrexham train, which meets the five o'clock train from Birkenhead, was crossing the suspension-bridge, it suddenly gave way, and carriages, tender, and passengers were all precipitated into the river Dee, at the bottom of which they now lie. The chain which connects the engine with the tender fortunately snapped, and the engine darting forward, the engine-driver escaped. A gentleman

Initial report from the *Liverpool Mercury*, 25 May 1847.

Douglas, John (1830–1911), Architect

Edward Hubbard in his biography of Douglas (*The Work of John Douglas*) stated:

> He was a first-rate church architect and in great demand as a designer of county houses. Douglas was influenced by the timber framing of Cheshire and the Welsh border and the late medieval brick architecture of Germany and the Low Countries, but his buildings were anything but copyist and bear a highly individual and nearly always recognisable stamp. They are marked by sure proportions, picturesque effects of massing and outline, careful detailing, and a superb sense of craftsmanship and feeling for materials.

John Douglas was an English architect based in Chester who designed over 500 buildings across the north-west of England, Cheshire and North Wales, including the Eaton Hall estate of the Duke of Westminster. His buildings can also be seen throughout the city of Chester and his output included churches, banks, shops, offices, schools, memorials and public buildings. His style was broad and featured a diverse range of architectural elements, borrowing from French, German and Dutch architecture. He worked during the period of the Gothic Revival, with the English Gothic style being a common feature in his designs. Chester is widely known for its Tudor black-and-white buildings. While many original examples still remain, this style was greatly augmented by the late nineteenth-century 'black-and-white half-timber revival'. Douglas' terrace of buildings on the east side of St Werburgh Street (1895–97) are regarded by architectural historians Edward Hubbard and Nicklaus Pevsner as his greatest work in Chester and the 'high point of the Victorian black and white revival in the city.'

John Douglas.

Born in Sandiway, near Chester, he trained in Lancaster before setting up his office, and initially his home with his new wife Elizabeth Edmunds, in 1860 at No. 6 Abbey Square, Chester, where he practised throughout his career.

Commissions came from a variety of clients, which included wealthy landowners and industrialists. He was especially favoured by the Grosvenor family of Eaton Hall and worked on a number of buildings from 1865 onwards, designing a series of structures for the first Duke of Westminster throughout the estate and surrounding villages, including farms, churches, lodges, schools, cottages and large houses, such as the Ferry House at Eccleston, St John the Baptist's Church, and the Lodge House in Aldford.

By the mid-1870s, the Douglas family had moved to No. 33 Dee Banks in Boughton, one of a pair of semi-detached houses (with No. 31) in an elevated position overlooking the River Dee, both designed and built by Douglas. Following the death of his wife in 1878, he built a larger Tudor-style house in its own grounds just a couple of hundred yards north of his present house. This was called Walmoor Hill, but soon acquired the local nicknames of 'Douglas' Castle' and 'Douglas' Folly'. Douglas died there in 1911 aged eighty-one, and was buried in Overleigh old cemetery, Chester.

His most popular lasting legacy is undoubtedly the Victorian Eastgate Clock, which has become an iconic symbol for the city. (*see* Victorian Eastgate Clock)

Bath Street. (Photo: Lewis Royden)

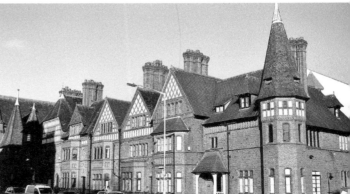

Nos 6–11 Grosvenor Park Road.
(Photo: Lewis Royden)

Eaton Hall

Eaton Hall is the country house of the Duke of Westminster, and was the preferred home of the present duke's father, Gerald Grosvenor, the 6th Duke (1950–2017). It sits within an estate of around 10,872 acres just to the south of Chester and near the village of Eccleston, and includes a variety of landscapes including woodland, farmland, parkland, formal gardens and even a disused Second World War airfield (RAF Poulton).

The Eaton estate was acquired by the mid-fifteenth century, when it is likely that the Grosvenors lived in a moated two-storey house, which is shown on a seventeenth-century estate map, and was still in existence by the end of the eighteenth century. Work commenced on a new house under the control of architect William Samwell in 1675, but between 1804 and 1812 that house was rebuilt in the Gothic style to a fantastic scale, designed by William Porden, completed after his death in 1822. It included as many Gothic features as the architect could cram in, from turrets, pinnacles and arched windows to octagonal towers and buttresses. The style was heavily criticised, not least by the diarist Charles Greville, who declared it to be 'a vast pile of mongrel Gothick ... a monument of wealth, ignorance and bad taste.' There were further modifications made by the 2nd Marquess, who inherited the house in 1845, but there was a complete transformation by Alfred Waterhouse between 1870 and 1882 at the behest of the 3rd Marquess Hugh Lupus Grosvenor, who inherited in 1869 and became the 1st Duke of Westminster in 1874. The core of the building was retained and Waterhouse either modified the exterior or completely rebuilt it, while adding a private residential wing for the duke and his family. He also constructed numerous outbuildings including the stabling, plus a chapel with a clock tower. Its appearance was much more aesthetic, and largely well received by critics.

However, by the mid-twentieth century it was becoming quite dilapidated, especially after parts of the hall were used as a military hospital during both wars and as a naval officer training college between 1943 and 1946. Furthermore, it continued to be used by the Army as a training school, where some 15,000 officer cadets were trained until the end of national service in 1958. Consequently, by the early 1960s the fabric had deteriorated so much that it was impractical to maintain it, and the house was demolished, although the outbuildings were largely preserved.

By 1973 a new hall, designed by John Dennys, was constructed on the same site, taking less than two and a half years to complete. A modern, flat-roofed structure in concrete and marble, its stark white appearance was out of keeping with its surroundings, and critics likened it to a county ambulance headquarters, while the Prince of Wales, a close friend of the 6th Duke and scourge of modern architectural carbuncles, dubbed it 'The Inn on the Park'.

The 6th Duke, Gerald Grosvenor, who inherited the estate from his father in 1979, decided to change its exterior to a design more in sympathy with the local landscape. Dennys Hall was recased to transform its appearance closer to that of a French château. The work began in 1989 and was competed in 1991, but still had its detractors, the editors of Pevsner (2011) describing it bluntly as 'Château style, Eaton style, but also Tesco style'.

Speaking to Sue Lawley on *Desert Island Discs* in 1995, after she had reminded him of Prince Charles' comment about the Dennys house, the duke laughed and candidly explained,

> I didn't like the house. We've now rebuilt it again – it seems to be a tradition in my family to never be satisfied with what they are living in at the time, and so therefore changing it. We didn't demolish it, but moved out of it for three years and then reconstructed the whole house.
>
> Sue Lawley: But it does seem a terrible shame that somebody who owns some of the most classically beautiful buildings in Britain lives in a kind of modernistic construction.

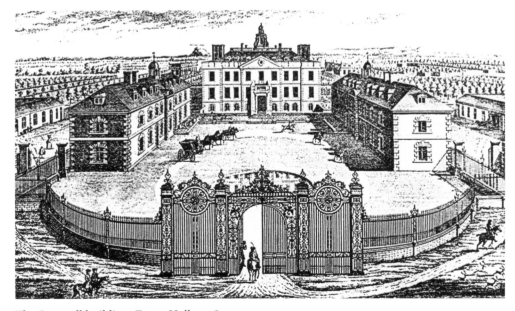

The Samwell building, Eaton Hall, *c.* 1675.

Duke of Westminster: Yes, I think it may perhaps seem odd. However, I think it is a piece of architectural history, like it or not, that I can leave behind me, and I like it very much. It no longer looks like the county ambulance headquarters or the fuhrerbunker, how someone once referred to it. It had so many names that there was one time when I was going to put up a sign with all the names on it and have a competition to choose one.

Although Eaton Hall is closed to the public, the extensive gardens are open on three days a year to raise money for charity.

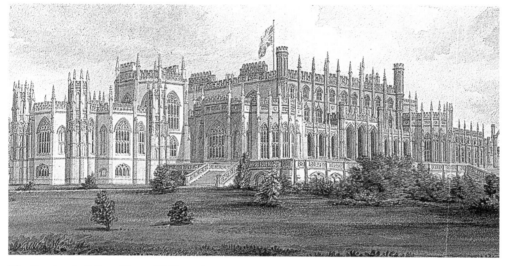

The Porden building, Eaton Hall, *c.* 1812.

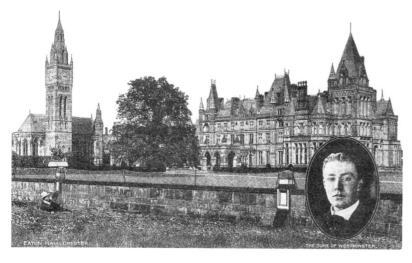

The Waterhouse building, Eaton Hall, completed 1882. Inset shows Hugh Grosvenor (1879–1953), 2nd Duke of Westminster.

F

Footballers

A number of international footballers have close ties with Chester, several of whom even played for the same Deeside Area Primary Schools team at different periods (and as professionals, later made 364 league appearances between them, and all captained their country).

Barry Horne

Barry Horne, who captained the Welsh national team and won the FA Cup in 1995 while playing for Everton, the team he supports, started out as a youngster, like several other internationals listed here, playing for Deeside Primary Schools. Like Michael Owen, he also had a number of junior games for Hawarden Rangers. As a senior player, as success did not come quickly, he concentrated on his education, gaining a first-class degree in chemistry and materials science at the University of Liverpool. He was halfway through a PhD before making his first major signing for Wrexham in 1983. By the nineties he was established at Everton, where from 1992 to 1996 he shone as a tough-tackling central midfielder. His decade-long international career saw him win fifty-nine caps and score twice. Now known for his regular punditry on BBC and Sky, he has since returned to the city in 2014 to the King's School, Chester, to become director of football and teacher of chemistry and physics.

Danny Murphy

Born in Chester in 1997 and a former pupil of Kingsway High School, he was the first Chester schoolboy player to play for England at full international level. At youth level he was first spotted by Dario Gradi, who signed him for Crewe, before moving to his boyhood club Liverpool in 1997, where he went on to play 170 games, scoring twenty-five goals. His time there included the unique cup treble in 2001, when Liverpool won the League Cup, FA Cup and UEFA Cup. Murphy was capped nine times for England and scored one goal.

Since his retirement in 2013, he has forged a successful career in the media, appearing as a regular pundit on *Match of the Day*, and on the UK radio station *Talk Sport*.

Michael Owen

Born in Chester, Michael's father Terry was a former professional footballer for Everton and Chester City. By the age of eight, Michael Owen was already playing for Deeside Area Primary School's Under-11 team. A year later he was captain, and as a ten year old he had scored ninety-seven goals in one season, beating Ian Rush's twenty-year record by twenty-five goals. He also broke Gary Speed's appearance records having played in all three seasons from the age of eight to eleven. After leaving Deeside, Owen attended Hawarden High School, North Wales, where he also played for the school team and Hawarden Rangers.

After signing youth forms for Liverpool, he attended the FA's School of Excellence at Lilleshall in Shropshire from the age of fourteen. At seventeen he played his first game for Liverpool on 6 May 1997, scoring on his debut against Wimbledon. His illustrious career with Liverpool, Real Madrid, Manchester United and England is well documented and needs no further mention here, but Michael has continued to live in the area with his wife and family, while running his racehorse training facility near Malpas.

Kevin Ratcliffe

Born in 1960 in Mancot, near Queensferry, just to the west of Chester on the Welsh border, Ratcliffe was another of this group to play for the Deeside Area Primary Schools. He joined Everton as an apprentice in 1977 and made his debut on 12 March 1980 at Old Trafford, before becoming a first team regular in 1982. By the following year he had been appointed club captain and three months later also captained his country in an international career that would see him win fifty-eight caps for Wales. By the mid-1980s he was established as the best central defender in the country and captained Everton through their most successful period in their history. After leaving in 1992 he later returned home to play for Chester under another former Evertonian Mike Pejic. He took over as manager in the summer of 1995, achieving some success, considering the off-field administration was then in absolute turmoil. After a spell managing Shrewsbury, he stepped away from management entirely, instead focusing his attention on working as a media pundit.

Ian Rush MBE

Ian Rush, born in St Asaph in 1961, was another who progressed through the ranks of Deeside Area Primary Schools and Hawarden Rangers youth team. There he was spotted by Chester youth coach Cliff Sear, who signed him to schoolboy forms before his fifteenth birthday, followed by an apprenticeship, after which Bob Paisley paid Chester £350,000, making him Britain's most expensive teenager.

In fact, Rush made his full Welsh debut before he even played his first game for Liverpool, his first cap coming on 21 May 1980, which was the beginning of an international career that would see him play seventy-three games over the next fifteen years, scoring twenty-eight goals.

He retired in 2000, returning to his boyhood club Chester City as manager in August 2004. After a bright start, performances started to dip, and with little recovery into the new year, it led to his resignation in April 2005.

Since November 2005, Rush has been involved in media work within the game, and working as a pundit.

Garry Speed MBE

Gary Speed was born in Mancot, Flintshire, Wales, and attended Hawarden High School, the same school as Michael Owen. He too played for the Deeside Area Primary Schools and lived on the same street as Kevin Ratcliffe, and was once his paperboy. When he left school in June 1988, he signed for Leeds United and by 1992 he was their player of the season in their First Division championship year. In total, he played in 312 games for Leeds United, scoring fifty-seven goals, building a reputation as a stylish attacking midfielder. By 1996 Joe Royle had signed him for Everton for a fee of £3.5 million – a dream move. This was the club he supported as a boy, and by the end of the season he was voted Everton's player of the year. He was capped eight-five times for Wales, while being captain on forty-four occasions. Speed was confirmed as the new Welsh national team manager on 14 December 2010 and was appointed a Member of the Order of the British Empire in the 2010 Birthday Honours for services to football.

Tragically he was found dead at the family home in Huntingdon, just south of Chester, on 27 November 2011, aged only forty-two.

Grosvenor, Gerald

For much of his adult life until his death in August 2016, Major General Gerald Cavendish Grosvenor, 6th Duke of Westminster, KG CB CVO OBE TD CD DL, had been a part of Cheshire life.

Despite his worldwide interests and travelling, plus undertaking some 200 public engagements a year for the number of charities he was involved with, he preferred a quiet family life at Eaton Hall, his Cheshire seat where he felt most at home. He was a landowner, businessman, philanthropist, a general in the Territorial Army and hereditary peer. Yet those who knew him said he was happiest with a cigarette and a can of diet coke – especially if he was in a field of prime beef cattle, or enjoying the company and conversation among soldiers.

Born in Northern Ireland in 1951, he grew up in the remote Ely Lodge on an island in the middle of Lough Erne, while his father served as Member of Parliament for Fermanagh and South Tyrone. Enniskillen, the nearest town, was 7 miles away, and he described growing up with two sisters Leonora and Jane as an idyllic, Swallows and Amazons childhood, enjoying much happiness and freedom playing in the Lough Erne islands.

However, the rural idyll was interrupted by him being packed off to boarding school at the age of eight, first to Sunningdale, then Harrow. His time away was unhappy and affected his education, achieving only two O Levels, preferring sports and the rural life. He was even offered a trial for Fulham Football Club by George Cohen, the England world cup winner, after impressing as a centre-forward, but was forced to decline. His father refused to sign the forms, disapproving of football as a career choice for an aristocrat, while objecting to 'all the kissing when they scored, and preferring the oval ball', as the Duke recalled later. (The sight of Gerry Grosvenor lashing one into the top corner from a George Best cross, after a through ball by Rodney Marsh would have been one to behold).

In 1978, he married Natalia Ayesha Phillips, a direct descendant of the Russian poet Alexander Pushkin, Tsar Nicholas I and King George II. Within a year, he had become the 6th Duke of Westminster on the death of his father, although he had effectively assumed responsibility for the management of the family's vast estates and business

interests at the age of nineteen, due his father's failing health. After the property crash of the early 1970s and the heavy mortgaging of the London estate to pay death duties, the business was in dire straits. However, by wisely surrounding himself with those with great acumen and business expertise, the Grosvenor estate has become one of the largest and most entrepreneurial privately owned international property companies in the world.

His passion in life has been the Territorial Army, which he joined as a young nineteen-year-old trooper in 1970, graduating from Sandhurst, then later becoming its commanding officer. By 2004 he had risen to the rank of major-general with a position of Assistant Chief of the Defence Staff for Reserve Forces and Cadets, effectively putting him in charge of Ministry of Defence policy for the reservists and cadets of all three armed forces. After a short period as Deputy Commander Land Forces (Reserves), he retired from the Armed Forces in 2012.

In August 2016 he suffered a heart attack while walking in the Trough of Bowland on his Abbeystead estate in Lancashire. He was airlifted to the Royal Preston Hospital, where he passed away on 9 August. He was buried in the family plot at St Mary's Church, Eccleston, with a memorial service held later at Chester Cathedral on 28 November, attended by the late duke's close friend Prince Charles and Camilla, as well as the Duke and Duchess of Cambridge.

The present duke, Hugh Grosvenor, 7th Duke of Westminster (born in 1991), who inherited the title from his father, lives and works in London as an accounts manager at a green energy company. He has three sisters, one of whom, Lady Edwina Louise Grosvenor, a goddaughter of Diana, Princess of Wales, is married to TV historian Dan Snow. Close ties with the royal family have been maintained, with Hugh Grosvenor being named as a godfather to Prince George of Cambridge in October 2013. The duke is the richest person in the world under the age of thirty, with an estimated fortune of £9 billion, and, unlike his father, he has been left a well-ordered Grosvenor estate.

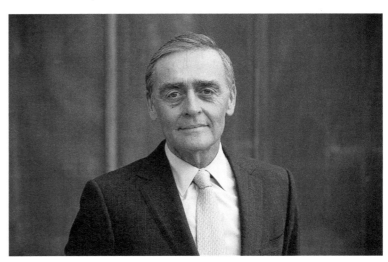

Gerald Cavendish Grosvenor, the 6th Duke of Westminster.

Harrison, Thomas (1744–1829), English Architect and Bridge Engineer

Although Thomas Harrison's work was not confined to Chester, he was responsible for a great number of the city's buildings and structures, and built a reputation as a major influence in the emergence of the Greek Revival in British architecture.

He studied classical architecture in Rome, and soon found commissions in Lancaster and Scotland on his return home. He first came to Chester in 1786 when he was asked by the city justices to design new buildings within the confines of the castle. He created accommodation for prisoners in a new county gaol, on a site sloping down to the river (which was demolished in the 1930s and replaced by the former Cheshire County Hall, now occupied by the University of Chester), but was also engaged to construct the rest of castle modernisation. What resulted is arguably the finest group of county buildings in England.

The whole of the castle outer bailey was rebuilt, and the new complex consisted of three main blocks, the centre building housing the Shire Hall, with its massive central pediment supported by twelve Doric columns (completed in 1802), while the flanking buildings contained the barracks on the left north-side wing, and the armoury on the right southern wing. His final building fronting the central perimeter, built between 1813 and 1815, was a monumental gateway or *Propylaea*, consisting of a central block, with an extending portico with a double colonnade of four Doric monolithic columns standing 18 feet high. This was flanked on both sides with two lateral pavilions that originally served as guardhouses. Harrison's neoclassical influence is clearly evident throughout the complex.

Many of his structures have survived, most of them now designated as listed buildings, such as the Commercial Newsroom (1807–08), the Northgate (1808–10) the Wesleyan Methodist Church (1811), Dee Hills House (1814), Watergate House (1820), and St Martin's Lodge, his own home (1822–23).

Towards the end of his career, Harrison worked on two bridges in Chester. The medieval old Dee Bridge was becoming inadequate for the increasing amount of traffic, and Harrison widened it in 1825–26 to provide a footway on the upstream side, while adding three new arches on the same side. However, despite the alterations, it was

clear a modern bridge was essential and Harrison's commissioned design resulted in the construction of the Grosvenor Bridge. Its single span was the longest single-arched masonry bridge in the world, a distinction it held for thirty years. Officially opened by Princess Victoria of Saxe-Coburg-Saalfeld (mother of Queen Victoria) on 17 October 1832, the first traffic began to use it a year later in 1833. Both bridges today are Grade I listed, and Thomas Harrison's model of the bridge can still be viewed nearby, set into the grassy bank on Castle Drive, below the City Wall. Originally made to convince the sceptics that his design would not collapse, this model is now Grade II listed.

Harrison lived with his wife, Margaret Shackleton, and their three children in St Martin's Lodge, where he passed away aged eighty-five in 1829. The building today, which overlooks the racecourse and the Roodee, is a traditional public house and restaurant, named The Architect in his honour.

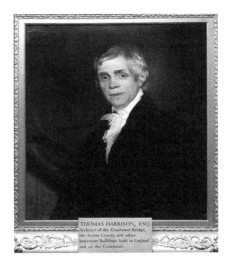

THOMAS HARRISON, ESQ.
Architect of the Grosvenor Bridge, the Assize Courts, and other important Buildings both in England and on the Continent.

Right: Thomas Harrison (1820) by Henry Wyatt (held in Grosvenor Museum, Chester).

Below: The Chester Castle complex designed by Harrison.

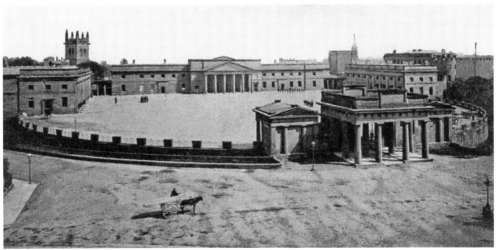

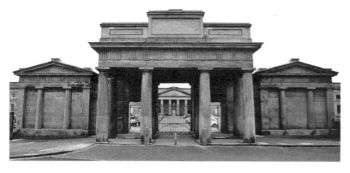

Chester Castle Propylaea.
(Photo: Lewis Royden)

Watergate House (1820).
(Photo: Lewis Royden)

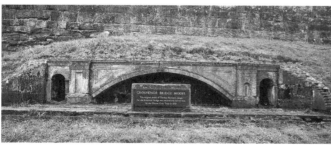

Harrison's model of the
Grosvenor Bridge below
the City Walls, Castle Drive.
(Photo: Lewis Royden)

Now known as The
Architect, the white building
is Harrison's former home,
St Martin's Lodge (1822–23).
(Photo: Lewis Royden)

I

Infirmary

By the eighteenth century the expanding city of Chester was poorly served regarding medical care and was in dire need of a new purpose-built infirmary. Therefore, when physician William Stratford died in 1753 and left £300 to endow a county infirmary, a committee was swiftly formed at the Chester assizes and an appeal for further subscriptions was drawn up.

Initially, the infirmary was housed temporarily in part of the Bluecoat School with the first in-patient admitted in 1756, and treatment was free to patients who were recommended by the subscribers. Meanwhile, work on the new building designed by William Yoxall commenced in 1758, and was completed three years later.

Despite the facility it provided for the poor of the city, it did not admit pregnant women, children under seven years, inoperable and incurable cases, or those with infectious diseases. Potential patients had to present themselves with a subscriber's ticket only on Tuesdays, although emergencies could be admitted at any time – at the discretion of the medical staff.

An early test came in 1772, when the infirmary was confirmed to have coped adequately with a major incident, when twenty-three people were killed and fifty-three injured in a gunpowder explosion at a puppet show in Watergate Street (*see* The Puppet Show Explosion).

A governor's report of 1807, declaring the building to be 'spacious and convenient', did not go down at all well with those actually using the facilities, and growing dissent fell on deaf ears. By 1824 the assessment of the infirmary had declined to 'essentially defective', especially when compared to modern facilities elsewhere. After much disagreement, county architect William Cole Jr was engaged to carry out a range of modifications and additions, to create more space and make more effective use of the building, which were completed by 1830. There were further extensions over the years, and when Edward V opened the new Albert Wood Wing with its six wards in 1914, the 'Royal' moniker was added to the name of the hospital. W. T. and P. H. Lockwood, who designed the new wing, added another in 1931, but during the 1990s when patients were transferred to the Countess of Chester Hospital, all the additions to the original building were demolished. This Grade II-listed Infirmary building has since been converted into apartments as part of the St Martin's Way/City Walls residential development.

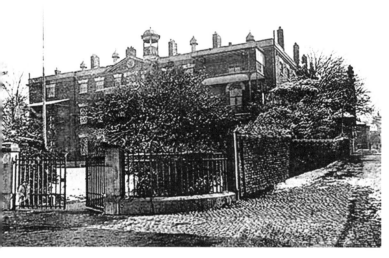

Chester Infirmary (1920s).

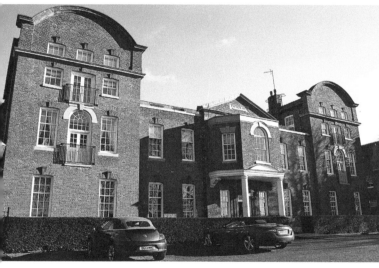

Left: The former Chester Infirmary restored and renovated. (Photo: Lewis Royden)

Below: Preserved stonework above the Doric entrance. (Photo: Lewis Royden)

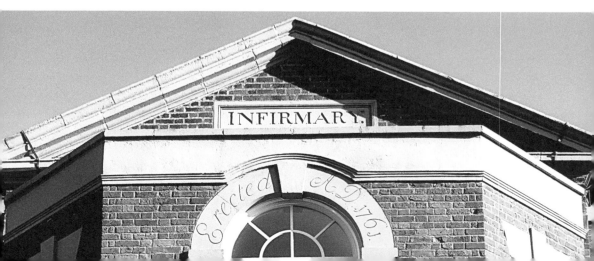

J

(St) John the Baptist Church – The Catastrophic Collapse of the Tower

There was a rumbling noise, which was succeeded by a terribly and indescribably drawn out crash, or rather rattle, as though a troop of horse artillery was galloping over an iron road; this was mingled with a clash of bells, and when it had increased to a horrible and almost unbearable degree, it suddenly ceased, and was succeeded by perfect stillness.

So wrote Revd S. Cooper-Scott, the rector of St John's, describing the dreadful, and no doubt heartbreaking collapse of the old Gothic tower of St John's Church in 1881. The historian Thomas Hughes, who lived nearby, was one of the first on the scene,

The night of the 14th and 15th of April, 1881, will be a melancholy one, and a memorable, in the history of the great Church of St. John's. On that night and a little after daybreak next morning, a calamity befell the church and the city, for which no amount of personal money sacrifice on the part of the citizens, or of their generous friends elsewhere, can ever adequately provide a remedy.

The grand old Perpendicular Tower, and even more grand and graceful Early English Porch, have both in one night virtually become things of the past, for they lie today heaped together in one sad, solemn, undistinguishable pile of ruin.

For a great many in the city it was seen as the inevitable consequence of ignored warnings and lack of funding. The local press reported,

For some time previous to the collapse of Thursday night it has been deemed unsafe to peal the bells, which still remain suspended in their places high up among the ruined remains of the old tower and many a passer-by has been hurried out of the immediate vicinity of the tower by occasional pieces of falling masonry which seemed to be a warning of danger and a mute appeal to the venerable structure for help in bearing the burden of decay which centuries of time had lain upon it. An ominous

crack extending from the summit to the base of the north-eastern side of the tower, has been strikingly observable for a long time, and lately it had increased in extent that a few days ago the danger was declared to be considerable, and steps were being taken to reduce, as much as possible, the probability of anything happening.

Cheshire Observer, 23 April 1881

The first collapse had taken place just after 10 p.m. Thursday 14 April, bringing dozens of shocked onlookers out of their homes to see the north-eastern section in clouds of rubble, but the final throes were still not done; at 4 a.m., on what was now Good Friday morning, there was a second collapse, leaving just the southern and western faces standing. While the main fabric of the Norman church was not damaged, much of the impact had been taken by the fine Norman porch, which was now a heap of debris. Miraculously, no one was hurt in the collapse, which would have been a different story if it had occurred a few hours later during the Good Friday services. The tower was later demolished, although a large part of the ruined base remains.

Throughout its existence, there has been a distinct lack of fortune regarding its towers. The disaster of 1881 wasn't the first to be witnessed. The central tower collapsed around 1470, and worse was to come with a further failure in 1572, followed by the partial demise of the north-western tower only two years later. Nevertheless, St John's survived the Dissolution of the Monasteries, owing its existence today to the nave being used as the parish church for the local community.

I have my own connection with this fine Norman relic as my direct ancestor, Alexander Royden attended the church from the 1600s and was buried there in 1719. His son Joseph was buried with him too only two weeks later, suggesting the same illness, leaving Joseph's wife Mary quite alone with her infant son John, who had been baptised in St John's two years earlier. John survived into adulthood and all Royden's in the Wirral and Liverpool are his descendants.

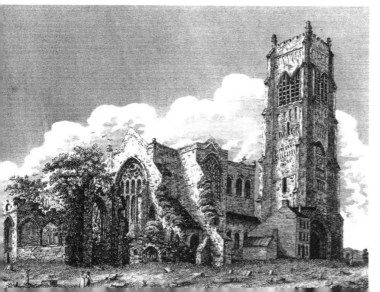

St John's Church, with its tower and abbey ruins (1818).

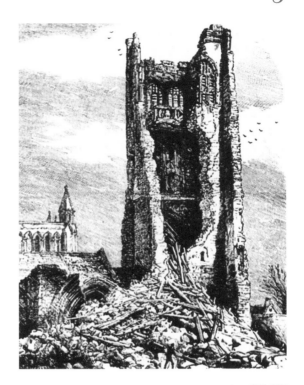

The collapsed tower of St John's Church, 1881.

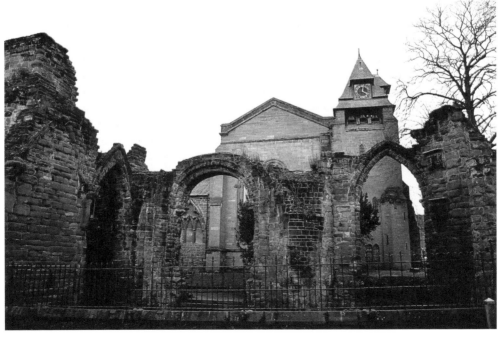

St John's Abbey ruins in front of the church and the Douglas 1887 clock tower. (photo: Lewis Royden)

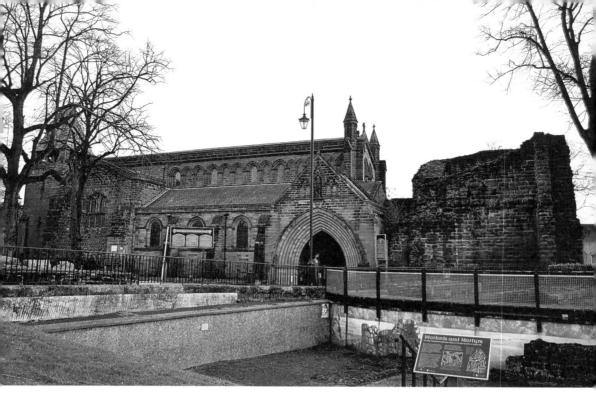

The 1882 Douglas porch (centre) with the remains of the tower to the right, viewed from the Roman Amphitheatre. (Photo: Lewis Royden)

Baptism record from St John's: 'Joseph son of Alexander Roydon was bapt this 12 November 1692.'

Kingsley, Charles – Writer and Canon of Chester Cathedral

Although nothing appeared in the local press, there must have been a few Cestrians concerned when they heard the name of the new canon appointed to Chester Cathedral in 1869. However, when he arrived the following year, they found a man who was not the devil incarnate they were expecting, but a gifted speaker interested in a broad range of cultural activities and natural sciences, and there was little hint of the socialist firebrand they'd been led to believe was coming into their midst.

Well known to the modern reader as the author of *Westward Ho!* (1855), *The Water Babies*, (1863), and *Hereward the Wake* (1866), Kingsley's output was prolific, publishing around twenty books, numerous sermons and an array of pamphlets covering a broad range of subjects, from political issues of the day to geology and botany. He also upset a great many conservative Anglicans with his outspoken support of his friend Darwin after he had sent Kingsley an advance copy of *Origin of Species* in 1859.

Many of his actions and writings reflect Christian socialism, although he could hardly be called a socialist. There is no doubting his sympathy for the Chartists and other working-class movements, having made rousing speeches and authored political pamphlets, but he was also fully accepted into the heart of the establishment, most notably the royal family, who engaged him as a tutor for the Prince of Wales (the future Edward VII) and as chaplain to the Queen. He was also Regis Professor of History at the University of Cambridge until his move to Chester.

After graduating from Magdalene College, Cambridge, in 1842, he took religious orders and was ordained later that year by the Bishop of Winchester to the curacy of Eversley in Hampshire, on the borders of Windsor Forest. Within two years he was appointed rector, and would remain so until his death. In fact, he was shown as being there with his family on the census of April 1871 during his time as canon of Chester, a reflection of how the appointment would require him to be in the city for only three months of the year.

Nevertheless, his effect on the community was considerable. His sermons drew large congregations, he started evening classes in botany at the City Library, which were

well attended, and as interest in his lectures grew, he began to lead field studies into the countryside, even hiring trains to go on longer distances to places of interest. This led him to found the Chester Society for Natural Science, Literature and Art, with many of his students as original members. This in turn played a crucial role in the founding of the Grosvenor Museum in 1885.

His time in Chester was cut short in 1873 when on the recommendation of Gladstone he was appointed canon of Westminster. On leaving Chester, the *Chester Observer* published a long article on 29 March 1873, concluding,

> Indeed, it may truly be said that Chester has been put in mourning by its loss of one of the kindest, most genial, and most popular of men. The Reverend Canon has addressed a letter to the Secretary of his Lecture Society in which he informs him of the fact that he has accepted the vacant stall at Westminster and feelingly states that he looks back longingly to Chester and the neighbouring mountains, and that his eyes fill with tears at the thought of breaking the connection with the place.

During his first year in his new office he visited his son in America, from which his health never recovered, and he died at the Eversley rectory in January 1875.

He published two works reflecting his time in the city: *Town Geology* (1873), a work based upon a series of lectures he gave at the society he formed, plus his walking tours with his students, followed by *Prose Idylls* in 1874.

Today, a blue plaque marks his Chester home in Abbey Square, and there is a bust in the Grosvenor Museum. The Chester Society for Natural Science, Literature and Art still flourishes as Chester Lecture Society, holding monthly meetings in the Museum Lecture Theatre (chesterlecturesociety.org).

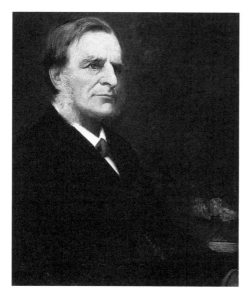

Portrait of Charles Kingsley by Thomas Walmsley Price (1855–1933), Grosvenor Museum, Chester.

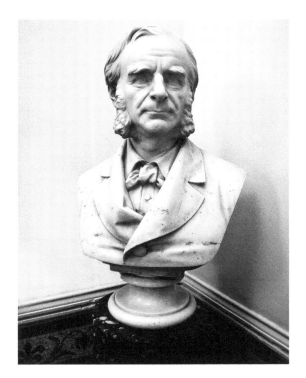

Charles Kingsley, marble bust (1876)
by Sir Thomas Brock (1847–1922) and
Richard Charles Belt (1850–1920),
Grosvenor Museum, Chester.
(Photo: Lewis Royden)

Charles Kingsley's Chester residence in
Abbey Square.

Lloyd, Hugh, MBE, Actor

For more than fifty years Hugh Lloyd was one of Britain's best-loved comedy actors, working as a partner with some of the funniest television comedians, most memorably Tony Hancock.

Born in Chester in 1923, the son of a manager of a local tobacco factory, and a piano-teaching mother (who ran Deva Ladies Singers female choir), he grew up in No. 7 Raymond Street while attending the King's School. Influenced by watching summer shows in North Wales during holidays in Llanfairfechan, his hero was Stan Laurel, and many of his parts during his career were similar to the hangdog, downtrodden character, who often wins through in the end against all odds.

Keen on amateur dramatics, he joined Upton Dramatic Society and appeared in their production of *The Housemaster* in 1939. However, his father, a strict Methodist, was concerned his son should have a more practical career, and after leaving the King's School, Lloyd worked as a reporter for the *Chester Chronicle* from 1939 to 1942, often reporting on Chester City football matches and local theatre.

By then the country was at war and Lloyd volunteered for the RAF, but was rejected due to severe hay fever. He was also rejected by MI5 for being too young, so instead went on a radio operator's course for the Merchant Navy at Colwyn Bay. In 1943, he joined ENSA (the Entertainments National Service Association), where he stayed for the remainder of the war. Subsequently, he turned professional, appearing in variety shows and pantomimes, as well as doing a stand-up comedy routine between the strip acts at the Windmill Theatre in London.

After a few small roles in the radio series *Hancock's Half Hour*, he became a regular in 1957 after it had moved to television. In the final series he appeared in the most famous episode of all, *The Blood Donor*, now an all-time comedy classic. From then on he was rarely off the screen, appearing regularly throughout the 1960s and 1970s in comedy sitcoms, including a long partnership with Terry Scott. He continued to appear as a guest in a variety of sitcoms, but also appeared in a number of stage plays and showed his versatility as a character actor in several TV dramas during the 1980s and '90s.

Although he had been living in Sussex for many years, he still kept in touch with the progress of his beloved Chester City FC, who he'd supported from his youth, by having

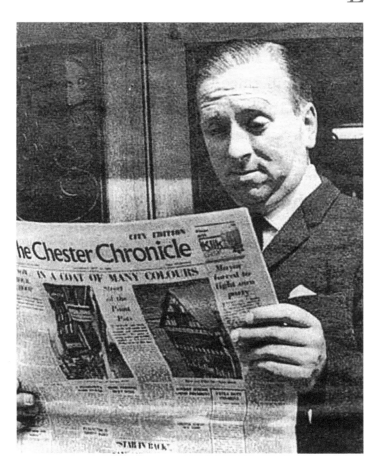

Hugh Lloyd.

the *Chester Chronicle* posted to him every week. Hugh also made a number of trips to his native city to take in a game as often as his work commitments would allow, and was often spotted at Sealand Road and the Deva Stadium even into his late seventies. His autobiography *Thank God for a Funny Face* was published in 2002 in which he devoted a chapter to his interest in football and Chester City in particular. Hugh was appointed a MBE for services to acting and charity in 2005, before passing away aged eighty-five at his home in Worthing on 14 July 2008.

Meacock, Lucy

Lucy Meacock is a familiar face in the North West, and has been on our TV screens since 1988 as a one of the main news presenters of ITV regional news programme *Granada Reports*. Born in South London in 1959, Meacock moved to Chester at the age of six and attended the Ursuline Convent in Dee House facing the Amphitheatre. However, before her final year Lucy and her family relocated to Australia, where she attended the independent Morongo Girls College in Geelong, Victoria. Her stay in Australia was brief, and after her return to the UK, she attended the independent Upper Chine School on the Isle of Wight. Intent on a career in journalism, Meacock jumped at the chance to return to Chester, where she started her apprenticeship on the *Evening Leader* and *Chester Chronicle*. After securing a post on BBC Radio Newcastle, she moved into TV news, moving to ITV Tyne Tees, BBC South East and ITV Anglia, before returning to the North West in 1988 to join the Granada Reports team and making Chester her home once more.

During her time with Granada, she chaired the ITV Granada late night discussion programme *The Late Debate*, as well as co-presenting *Granada Upfront*, a live regional debate programme with Tony Wilson. In 2001, Meacock won two Royal Television Society awards for the *Manchester Bomb Programme* and the *Organ Retention Scandal Debate*. In 2007, she joined the ITN produced *ITV News* weekend bulletins, which until August 2009 she regularly presented, but for family reasons she returned home and rejoined ITV Granada Reports in July 2011. Lucy continues to live in Chester.

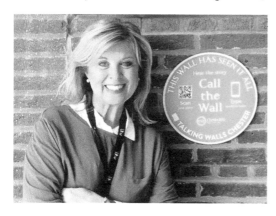

Lucy Meacock promoting the Chester Talking Walls project.

Northgate Gaol and a Drunken Hangman

Although Chester was becoming a popular tourist destination during the nineteenth century, especially after the coming of the railways, the city had also developed a rather dubious reputation as a destination for more ghoulish sightseers, intent on an entertaining day out to watch another miserable wretch end his life on the end of a rope.

Originally held on market days, public executions were intended to show an example of the strong arm of the law to local citizens, but they soon became a day of public entertainment, and another excuse for drunken revelry, until the practice was ended in 1868.

The city even had its 'chief hangman'. In a career that spanned twenty-four years from 1812 to 1835, Samuel Burrows despatched over fifty criminals, of which around forty-five were in Chester. Burrows was well known around the city, just as much for being a boorish drunk as for his grim trade. He frequently appeared before the magistrate himself, either for drunken behaviour or assault, both as accuser and accused, as he was much disliked throughout the locality. In one incident he was so intoxicated after drinking away his latest hanging fee that he was found slumped in a gutter. Helpful citizens loaded him into a wheelbarrow and, accompanied by a crowd of baying youths who had tied a noose around his neck, was carted off to the House of Correction a few yards from the Northgate and dumped outside. He spent the night confined within, before his sheepish court appearance the following morning. There he was admonished by the magistrate for being disgracefully drunk on Good Friday and fined 5s with costs.

Born in 1772 near Nantwich, Burrows worked as a butcher, a servant to a surgeon (clearly making use of previous experience), as a member of a press gang, and as a rat and mole catcher for which his skills in Chester were well known. Towards the end of his sorry life he spent time with local clergymen in an attempt to repent his past sins, while forgiving those who had wronged him, although not all it seems.

He is said to have died in peace with all the world, except the editor of the *Chester Courant*, whom he declared he would never forgive in this world, or in the next, for having announced his death a week before it occurred.

Chester Chronicle, 23 October 1835

The gaol had been housed for centuries within the medieval Northgate, with the earliest documentary reference to its use being made in 1321. By the early nineteenth century the building was in a very grim condition, especially the goal facilities, which historian Joseph Hemingway described in volume one of his *History of Chester* (1831):

> This ancient gate, over which was a mean and ruinous gaol, was an inconvenient and unseemly pile of building. It consisted of a dark, narrow, and inconvenient passage, under a pointed arch, with a postern on the east side, and the entrance to the gaol on the west. Immediately under the gateway, at the depth of some thirty feet from the level of the street, was a horrible dungeon, to which the only access of air was through pipes, which communicated with the street. In this frightful hole, prisoners under sentence of death were confined - itself a living death.

The decrepit gaol was finally closed in 1807, and prisoners were transferred to the new prison facilities at the castle, while the demolition of the whole medieval edifice of the Northgate and gaol commenced shortly afterwards. It was replaced by the present bridge gate, built between 1808 and 1810 by Thomas Harrison (*see* Thomas Harrison), in the neoclassical style he had already utilised to impressive effect elsewhere in the city.

Just to the west of the canal road bridge in front of the Northgate, another high-level narrow bridge can be seen over the canal, joining the city wall to the Bluecoat building. Built in 1793 and originally flanked with iron railings, it was known as the Bridge of Sighs, and formerly linked the gaol with Little St John's Chapel. Condemned prisoners were supposedly escorted to a small room there, where they were given the last rites, before retracing their steps, then on up to the top of the Northgate bridge where the drop scaffold and the hangman (hopefully still reasonably sober) would be waiting, ready to put on a show for the packed crowd below.

'Samuel Burrows, commonly called Sammy Burrows, the Executioner of this city.'

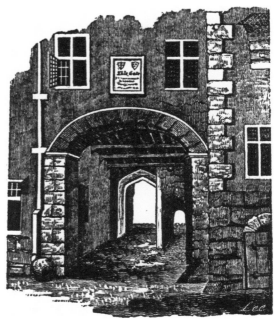

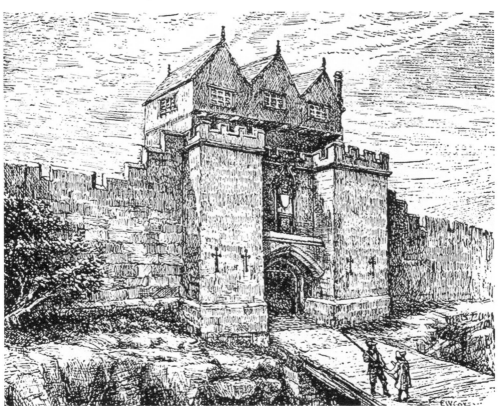

Right: The medieval Northgate (interior),
'a dark, narrow, and inconvenient
passage, under a pointed arch'.

Below: The medieval Northgate exterior.

Thomas Harrison's Northgate (completed in 1810), *c.* 1905.

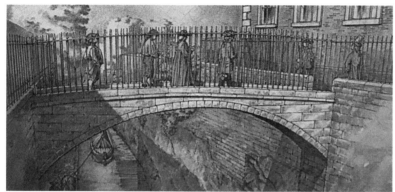

An artist's impression of a prisoner walking across the Bridge of Sighs to the Chapel of Little St John, *c.* 1790. (Original image: Cheshire West and Chester Council)

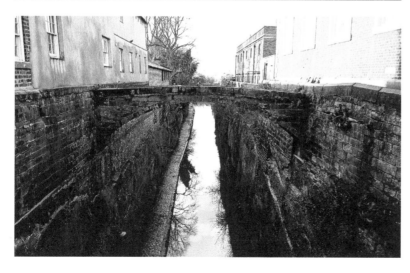

The Bridge of Sighs today. (Photo: Lewis Royden)

Overleigh Cemetery

The authors of the *Buildings of England* series once described this cemetery on the south side of the River Dee in Chester as 'highly romantic' and 'eminently picturesque'. Although the cemetery today lies either side of Overleigh Road, the original part on the river side was laid out between 1848 and 1850 by Lister with entrances and chapel by local man Thomas Mainwaring Penson (1818–64) and was opened on 12 November 1850. Today it is Grade II listed in the National Register of Historic Parks and Gardens. At one time the cemetery contained a lake with three islands, two chapels, two lodges, serpentine paths and trees, and a house for the chaplain; however, the lake, lodges and chapels no longer remain. It was extended to the south in 1879, where the west chapel and a cenotaph, in the form of a Cross of Sacrifice to those who died in the First World War, are also now Grade II listed. There are 197 Commonwealth War Graves, 127 of which are First World War casualties and sixty-nine from the Second World War. The collected plot is small, containing only thirty-two graves from both conflicts, with the remainder dispersed throughout the cemetery with no uniform assemblage. A great number are of those brought to local hospitals from the battlefields.

Although few of the graves throughout the cemetery are remarkable, some of the stories about their incumbents certainly are. To highlight just three, interred here is Mary Jones who died in 1899, described on her death in the local press as 'Death of a Local Celebrity', not least as this local furniture seller reached the ripe old age of eighty-seven, but also for the fact that she gave birth to thirty-three children along the way, including fifteen sets of twins – reputedly.

A grimly realistic effigy was lain as a memorial to three-year-old Mabel Francis Ireland-Blackburn, who was said to have died after choking on chewing-gum (although the official recording was whooping cough) in 1869. A notice was placed near her grave as a warning to deter youngsters from engaging in the foul habit, so the legend of the 'Chewing Gum Girl' was born. It bore the verse:

> Chewing gum, chewing gum, made of wax
> Brought me to my grave at last.
> When I die, God will say
> 'Throw that dirty stuff away!'

Local children would frequently sing the lines as a skipping song, while flowers are often to be found anonymously laid at her grave.

Uniquely bizarre was William Biddulph Cross, a man known for his bottled cures for skin conditions, as well as his skills in shoemaking, book binding and picture framing. He was fascinated by anatomy and possessed a large collection of books and drawings. All perfectly normal. What intrigued the local community was the coffin he built for himself out of matchboxes. It was made from thousands of them, packed with wood and framed in black wood and took ten years to complete. He intended to fit a light too, and in a space in the lid he installed a battery, with wires and zinc plates throughout the coffin.

After his death on 5 September 1908 aged eighty-five, his coffin was put on display for two days at the undertakers, Messrs Dutton & Sons, in Frodsham Street. Hundreds of curious and inquisitive locals streamed through the shop, eager to have a look. Even the day of the funeral was a circus. On a rainy afternoon the hearse left his house in Crook Street, passing hundreds of people crowding along the Rows in Watergate Street and Bridge Street, straining to catch a glimpse of the procession. The hearse was hung with wreaths, but the focus of interest was the coffin exposing the battery on the lid in full view. Police had to hold back crowds lining the path to the grave in Overleigh, where the battery was disconnected and removed, committing William Cross to eternal darkness.

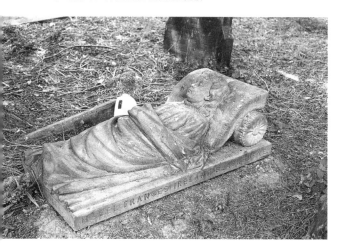

The 'Chewing Gum Girl' memorial – Mabel Francis Ireland-Blackburn. (Photo: Richard Minshull)

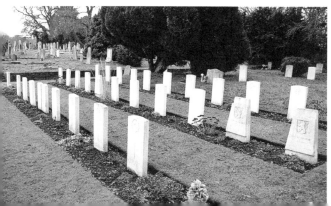

Commonwealth War graves, Overleigh Cemetery (south). (Photo: Lewis Royden)

Pickup, Ronald – An Actor for All Seasons

Veteran English actor Ronald Pickup has been a familiar face on stage and screen since becoming a leading man in 1964. His work has covered around fifty stage roles, a similar number of TV roles and over twenty films. Born in Chester in 1940 to parents Eric and Daisy, his father was a lecturer in English and French at the then Diocesan Training College for Teachers, now the University of Chester, while the family lived in St Chads Road, nearby. Young Ronald's first experience of acting was at the age of five, when he joined his mother Daisy (née Williams) on stage at the Royalty in a pantomime.

Ronald was a pupil at the King's School in Chester, before going on to read English at the University of Leeds, where he gained a scholarship to attend RADA from 1962 to 1964. Not only did he graduate in 1964, but he also met his wife Lans Traverse there. He found TV work straight away, with a part in a season one episode of *Dr Who* with William Hartnell, entitled *The Tyrant of France*, playing a surgeon during the French Revolution. He went on to star in *The Day of the Jackal, Mahler, The Thirty-Nine Steps, Zulu Dawn* and the Bond movie *Never Say Never Again*.

He has also had a long career on the stage, and spent a decade at the National Theatre where he acted with Olivier on several occasions, most notably in *Three Sisters, Long Day's Journey into Night* and in Olivier's last stage performance.

On television he has rarely been off our screens, regularly appearing in dramas such as *Foyle's War, Midsomer Murders, Waking the Dead, The Bill, Silent Witness, Sherlock Holmes, Inspector Morse, Holby City* and *Lark Rise to Candleford*.

His daughter Rachel Pickup is also an actor and they starred together in the *Midsomer Murders* episode, *The Magician's Nephew* in 2008, and also *Schadenfreude* (2018), which is a real family affair, with his son Simon as writer and director.

In his seventies he continues to appear on the screen, with roles in *Downton Abbey, The Crown, The Best Exotic Marigold Hotel* and its successful sequel, and as Neville Chamberlain in *Darkest Hour*.

In 2011, Ronald returned to Chester and his old school where he opened the Vanbrugh Theatre in the King's School, and recalled putting on plays in the school refectory in the days when boys were taught in a building next to Chester Cathedral.

Port of Chester

The River Dee has been used for trade from at least the Iron Age, while a Roman harbour lay to the west of the fort, but precisely where remains uncertain. Although a section of Roman stonework is uncovered on the perimeter of the racecourse below Grosvenor Road, and usually referred to as the Roman Quay, it may have been part of a longer perimeter wall enclosing the western Roman settlement.

As well as trading vessels, the Saxons are thought to have used the haven for their naval ships, and after the Norman Conquest, a number of wharves, mainly of timber, were constructed below the castle near the Bridgegate, and also downstream of the Roodee. To give easier access to the river, the Shipgate was erected just a few yards west of the Bridgegate during the medieval extension of the town walls, while at the north-west corner of the walls a defensive spur was constructed towards the retreating river, with the new Water Tower built in 1320 at its end. During this period the high tide lapped around its base and through the linking arch behind it (still in situ), while boats were moored by ropes tied to the iron rings set in its wall.

However, silting had long been a problem – the Roodee is a clear visible example of tidal deposits, the river gradually sweeping further away from its original course, which was closer to a line running to the west of Grosvenor Road, towards City Walls Road and the Water Tower. As early as the fourteenth century, documents refer to 'the ruinous state of the haven'.

By the sixteenth century city trade was being affected so badly, with ships being unable to reach the port, that quaysides such as Neston and Parkgate were being constructed on the west coast of the Wirral, from where cargoes were brought to the city by road. Surveys to improve the river were commissioned as early as 1674, but it wasn't until 1733 before engineer Nathaniel Kinderley commenced work. On 3 April 1737,the water flowed into the 'New Cut' for the first time, from Brewer's Hall near the Cop to the Wepre Gutter, which became the newly constructed Connah's Quay, while the raised embankment works along its length were completed by 25 March 1740.

With this resurgence in fortune, attempts were made to develop the harbour facilities. Much of this was concentrated in the section between the Roodee and the New Cut, where new warehouses were constructed, plus a new access road to the Watergate called New Crane Street. Further north, a new quay and a warehouse were built for the cheese merchants to further exploit their lucrative coastal trade.

However, it was all futile as the decline was irreversible. In 1845, officials from the Tidal Harbour Commission visited Chester to assess the state of the port and river, and gave its damning verdict:

> Every sort of impediment to navigation exists in this river: at the town is an ancient weir or causeway ten feet high which prevents the tide coming up and consequently destroys the scour of the river by the return of the tidal water; the freshes* in the

river are also prevented from clearing the bed of the river of the sand; water which ought to flow down the river is so abstracted by the Ellesmere canal and emptied into the river Mersey; there is a lamentable deficiency of lights of beacons and of buoys. The usual consequences have followed: shipwrecks, loss of trade, refusal of freights to Chester - so that there is not one third of the trade to the town there was so lately as three years ago.

<div align="right">

Visitations of the Tidal Harbour Commission to
Chester, *Naval Chronicle* (1845) p.711-12

</div>

[* The increased current of an ebb tide by means of a flood of fresh water flowing towards the sea]

There was some success in shipbuilding, especially during the early years of the nineteenth century when production was on a par with Liverpool. It was not unusual to see ten or twelve vessels on the stocks below Crane Street at any one time, the main yards being those of Cortney and Troughton, where around 250 men were employed. The last yard to close was Crichton's at Saltney in 1935.

Today there is little left of the port infrastructure. A new promenade lines its length with modern residences now occupying the prime riverside locations. A block of eighteenth-century warehouses, however, can still be seen at New Crane Bank.

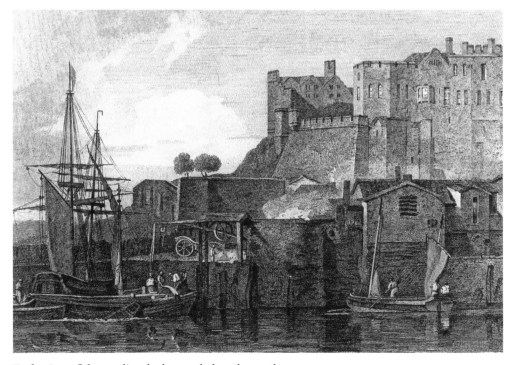

Early view of the medieval wharves below the castle.

Modern view of the Water Tower and the tidal arch behind it. (Photo: Lewis Royden)

Extract from John Stockdale's map of Chester 1795, showing the late eighteenth-century development of the port. New Crane Street is in the centre with the line of new warehouse towards the river. The original canal basin is shown, plus the Cheese Wharf and warehouse at the top.

Right: Extract from McGahey's aerial view (1855) showing the New Crane Street port (centre), the New Cut from the Cheese Wharf (far right) and the canal complex (bottom right).

Below: The port and canal complex by 1905.

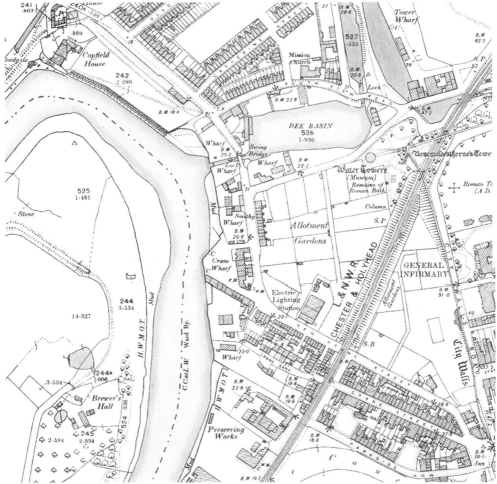

New Crane Street warehouses today. (Photo: Lewis Royden)

New Crane Street warehouse and the modern promenade. (Photo: Lewis Royden)

View of the former New Crane Street wharf site from the New Cut/ Cheese Wharf. (Photo: Lewis Royden)

Puppet Show Explosion

When children skipped through the streets of Chester on Bonfire Night in the late eighteenth century singing 'Remember, remember, the fifth of November', there were many in the city who just wanted to forget it.

For them the innocent rhyme brought back appalling memories of one of the most shocking events ever witnessed in the city, with scenes unlikely to have been seen since Chester was under siege during the English Civil War in the 1640s.

While revellers were enjoying their increasingly unruly and often violent annual celebrations around the city streets and taverns, a rowdy evening was being enjoyed at Eaton's Room, above a grocer's warehouse on Common Hall Street, to the rear of the southern side of Watergate Street Rows, accessed through a narrow alley. There in a crowded room showman George Williams was entertaining his audience with his Punch and Judy puppet show, no doubt with the characters that night including Guy Fawkes and James I, to whip up more raucous behaviour, as one or the other gets hit over head with Punch's truncheon. Then, without warning, the evening came to a horrifying conclusion when the building was torn apart by a huge explosion.

Just three days later the minister of the nearby Crooks Lane Unitarian Meeting House Mr J. Chidlaw described the events within a sermon preached to his congregation:

> On the 5th of November, 1772, about nine o'clock at night, the inhabitants of this city were alarmed by a sudden shock, resembling an earth quake. It was soon known to be occasioned by the blowing up of a large building in Watergate Street, in which was assembled a great crowd of people, to attend a Puppet Show. Unhappily, under the show-room was a Grocer's Warehouse, in which was lodged a large quantity of gunpowder. It is not certainly known by what accident it was fired, but the effects were terrible beyond expression. The whole building (the timber and walls of which were remarkably strong) was in a moment levelled with the ground, and some of the adjoining houses greatly shattered and damaged.
>
> J. Chidlaw, *A serious call to regard Divine Providence, a sermon preached at Chester, November 8th, 1772, on occasion of the dreadful calamity that happened there, on the 5th of the same month, by an explosion of gunpowder.* (1772)

A few days later the incident was reported in more detail in the local press:

> every person who shewed the least signs of life, should be immediately carried to the Infirmary, where the Physicians and Surgeons would be ready to administer every possible means of relief. The number admitted that night was 33, and 20 since, in all 53.
>
> A clean bed was provided for every patient, before the unfortunate sufferer could be stripped, which, in general, was by cutting off the clothes, to prevent the agony of pulling those limbs which were broken, burned, or bruised.

In this tremendous scene of horror and confusion, that no possible means of relief might be omitted, which their humanity and skill could suggest, the Faculty assigned different offices to different persons; some were employed entirely in bleeding all who required such an evacuation; others washed several times over all the burns and bruises with Goulard's cooling water, which seemed universally to have an excellent effect; the rest were engaged in setting fractured bones, reducing dislocations, &c.

Adams's Weekly Courant, Nov. 9, 1772.

(*see* Infirmary)

Casualty figures have varied between these contemporary accounts, but it would seem that around twenty-three were killed at the scene, with a similar number succumbing to injuries shortly afterwards, and around a further sixty badly hurt, bringing the total affected to around 106.

The buildings concerned no longer exist, nor does the alley, which from then on was called Puppet Show Entry, having all disappeared by the mid-twentieth century. Access to it was a couple of doors down from the Bishop's Palace, close to No. 51, but maps of the early twentieth century show its likely position.

Despite there being no trace of the alley or site, this was probably the worst single disaster the city has witnessed, and it is shameful that no memorial marker on Watergate Street commemorates this forgotten event.

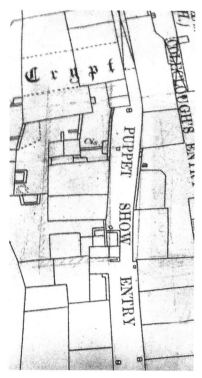

Map showing Puppet Show Entry before its removal.

Q

Queen Hotel

Once the station opened on 1 August 1848, it soon became apparent that there would be a demand for hotel facilities, especially as Chester was witnessing an increase in tourism. Architect T. M. Penson was commissioned, and the result was the impressive Queen Hotel, completed in 1860, constructed in Italianate-style brick and stucco, with a slate roof, and thought to be the first purpose-built railway hotel in the country. Its location couldn't be more perfect for travellers – facing the station on the corner of City Road and Station Road with a covered walkway linking the two buildings added shortly after. The hotel was 'up-market' from the outset, targeting first-class clientele, while the lower classes would be catered for at the Queen Commercial Hotel on the opposite corner (later known as the Albion and the Town Crier) built in 1865, a building that would stand out in an ordinary street, but overshadowed by its showy neighbour here. The two hotels were linked by an underground passage, although this is now bricked up.

The Queen's main porch facing the station gives a dramatic view for travellers emerging onto the forecourt, with its Corinthian columns and seven steps leading up to the entrance. On the pediment is a statue of Queen Victoria by Thomas Thornycroft, although the original was replaced in 1963.

Yet disaster struck within eighteen months of opening, when the hotel was gutted by fire in the early hours of 26 November 1861:

> On the evening of Monday, November 25, at the hour of five o'clock, the building in question was one of which Chester might be proud, so far as the formation of rough bricks and mortar by skilled hands into an elegant structure was concerned. During that day, it is fair to presume that the usual good business attached to the hotel had been carried on in the customary style. The gay joke and merry laugh had resounded within its walls, and the usual quantity of good eating and drinking had been consummated. The fair managers were smooth, easy and comfortable – the servants looking sleek, rosy and well fed.
>
> By five o'clock on Tuesday morning, November 26 – a short space of 12 hours – the whole edifice was a charred wreck, reeking with moisture and smelling abominably. What a contrast? How futile all human hopes and expectations!
>
> *Chester Observer*, 30 November 1861

After this flowery prologue, the journalist reported that the fire was spotted by a passenger waiting outside the station, who saw flames coming from a chimney to the rear of the roof. The alarm raised, an engine arrived from the nearby lead works in minutes. Despite the swift response, they searched for water without success. Hoses had been run into the station to try and source a water supply but to no avail, and it took them over an hour to finally uncover the grid access, concealed under a layer of gravel just yards from the front of the hotel.

In the meantime, as the fire inevitably gained hold, engines were despatched to the scene from around the locality, including two from Birkenhead and Crewe, which arrived by special trains at half past seven, although their effectiveness was delayed by this search for water, while floor after floor at the rear of the building came crashing down. Servants, with many of the gathered crowd volunteering to help, began transferring expensive furniture to waiting trucks for storage in the station. Even the army turned up to help when Captain Humberston arrived from the castle with his section of rifles, who marched in and kept guard over the furniture and kept the crowd back. In fact,

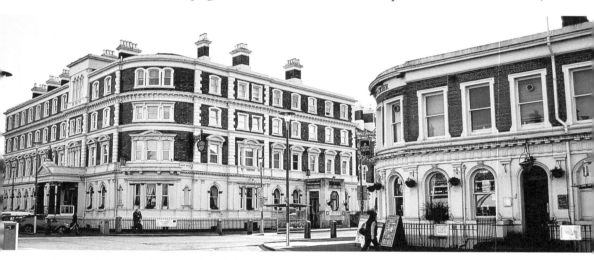

Above: The Queen Hotel (left) and the Town Crier. (Photo: Lewis Royden)

Below: The linking walkway to the station and coach arch. (Photo: Lewis Royden)

there were hundreds gathered on the city walls where occasional shrieks and moans could be heard as more sparks flew into the night sky and timbers crashed. Others were enjoying the spectacle, one turning to his friend was overheard saying, 'My eye Jim, it do burn, don't it? We arn't had such a fire in Chester since I don't know when!'

Recovery was swift: the hotel still had use of the wings, while Penson was again summoned to oversee the rebuild. He was assisted by Liverpool architect Cornelius Sherlock, who would soon make his name there designing the acclaimed neoclassical Walker Art Gallery and Picton Reading Room. The hotel, which reopened in 1862, was rebuilt to the same plan, but without its high roofs and viewing platforms, although the art deco porch in Portland stone facing City Road feels out of place.

Today the hotel is still just as impressive and is a designated Grade II-listed building.

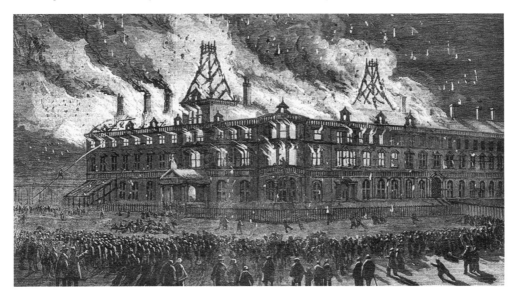

Above: The fire of 1861 (*Illustrated London News*, volume XXXIX, 7 December, 1861).

Right: Queen Victoria statue over the entrance porch. (Photo: Lewis Royden)

Rows, The

Next after its wall – possibly even before it - Chester values its Rows, an architectural idiosyncrasy which must be seen to be appreciated. They are a sort of Gothic edition of the blessed arcades and porticos of Italy, and consist, roughly speaking, of a running public passage tunnelled through the second storey of the houses. The low basement is thus directly on the driveway, to which a flight of steps descends, at frequent intervals, from this superincumbent verandah. The upper portion of the house projects to the outer line of the gallery, where they are propped with pillars and posts and parapets. The shop fronts face along the arcade and admit you to little caverns of traffic, more or less dusky according to their opportunities for illumination in the rear. If the picturesque be measured by its hostility to our modern notions of convenience, Chester is probably the most romantic city in the world. Chester is still an antique town, and medieval England sits bravely under her gables. Every third house here is a 'specimen' – gabled and latticed, timbered and carved, and wearing its years more or less lightly. These ancient dwellings present every shade and degree of historical colour and expression.

Henry James, 'Chester' from *English Hours* (1905)
(An essay on a visit to Chester in 1872)

A wonderful piece of romantic realism composed a century and a half ago, through the American eyes of the author better known for *The Turn of the Screw* and *The Portrait of a Lady*, is still a recognisable image to the modern visitor despite some of the changes made since.

The Rows are unique, and present an iconic view of the city, making Chester instantly identifiable wherever such images are viewed. They are arguably the city's most famous architectural feature and are found on the four main central thoroughfares: Eastgate Street, Watergate Street, Northgate Street near the Cross, and Bridge Street, although they also once extended down to Lower Bridge Street. At street level, often partly below ground was the undercroft (*see* Undercrofts), some of stone, some in timber, but strong enough to support the storeyed building above. Although the design of the medieval buildings is replicated in other towns

elsewhere, the undercroft or cellars were usually entirely below ground. However, in Chester, either due to high level of bedrock or the build-up of rubbish since the Roman times (especially when compared with the level of adjacent remains of Roman floors and hypocausts), it uniquely led to the undercrofts being exposed to street level.

The first floor consisted of the gallery to the street front, with the shop or commercial premises set back behind, which also contain the hall, usually at right angles to the front, which functioned as the main living room. On the second storey, which was constructed over the gallery, therefore creating a covered walkway, was the private living accommodation and other residential rooms. In some cases, the residence and shop were in different ownership from the undercroft. The Row walkway also provided a means of limiting the number of stairways from the street without restricting access to the first-floor premises.

Those that are of medieval origin, of which there are several, have been shown in recent studies to have remained in the form they are today from at least the mid-thirteenth century.

The walkways running through adjacent properties in different ownership, however, was remarkable. The precise origin of this as a public thoroughfare has been lost. It is possible that a single early development somewhere in the city influenced others to follow, or there may have been rows of linked commercial premises housing a similar trade. It could also be as a result of the co-operation of members of the same craft, or guild, to promote their commercial business.

The gallery (or stallboards) between the walkway and the front of the property was also part of the private ownership, but over time it gradually attained the status as a right of way under civic control, although it isn't clear when this was acquired. Initially, they were probably created for shopkeepers to use the space to display wares (and some still do), but under the local law they could not prevent through passage.

During the eighteenth century many of the half-timbered medieval buildings were refronted in brick, while the jettied storeys were cut back to enable a full flat façade. Consequently, much of the original timber framing is still in situ, with the row level being preserved in some cases. Nevertheless, the extensive rebuilding of the town as it moved into more prosperous times, and the desire to upgrade private housing, resulted in the loss of several sections, most notably in Lower Bridge Street.

With the growing influence of the vernacular black-and-white half-timber revival from the mid-nineteenth century, promoted by architects such as John Douglas (*see* John Douglas), this resulted in a number of new 'fake' buildings on the Rows, but in a number of cases mock-Tudor façades actually covered over original medieval buildings.

One exceptional building to survive is the thirteenth-century Three Old Arches in Bridge Street, which retains much of the original stone walled medieval hall set at right angles to the front, as well as its undercroft. The shopfront is thought to be the earliest to survive in England.

Plan of a typical medieval row house.

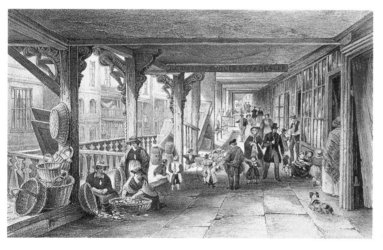

Watergate Street Row (G. Pickering, *c.* 1840).

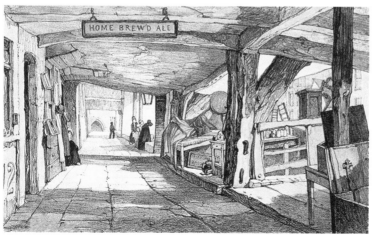

Eastgate Street Row (John Skinner Prout, *c.* 1845).

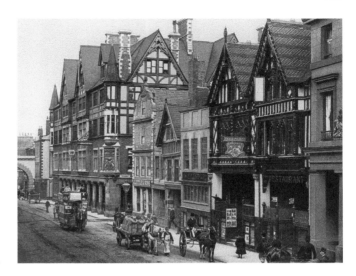

Eastgate Street Row, *c.* 1890.

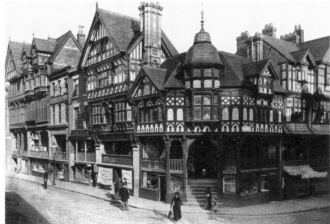

Eastgate/Bridge Street corner, *c.* 1895 (No. 1 Upper Bridge Street East). An example of the nineteenth-century vernacular revival. Built in 1888 by T. M. Lockwood.

Watergate Street Row showing the medieval arches. (Photo: Lewis Royden)

Shropshire Union Canal

After a number of false starts in Chester's attempt to jump on the national 'canal mania' bandwagon and boost its flagging port, the long-awaited Chester to Nantwich Canal was finally opened in 1779. However, the original hope of investors was that it would also link with the Trent & Mersey Canal at Middlewich, but this was abandoned, leaving Nantwich as a dead end.

> This branch [Middlewich], intended for bringing salt to Chester, was not executed, the expenses amounted to £80,000 and the shares became perhaps the most depreciated of any concern in the kingdom, being sold at one time for less than 1 per cent of their original value. When this project was first entered upon, the good folks of Chester appear to have thought that their fortunes were about to be made; the cutting of the first sod was celebrated by public rejoicings; and almost every one that could by any means scrape together a hundred pounds, was anxious to embark in this golden scheme, by purchasing a share in it.
>
> Joseph Hemingway, *History of the City of Chester*, Vol II (1831), p.324

When this was written in 1831 about the failed Middlewich branch in the 1770s, the effects of the loss were still raw. It was a disaster for investors, and not one dividend was paid out between 1772 and 1813. Once the Wirral line opened to Netherpool on the Mersey (later to become Ellesmere Port) and the canal was linked from Nantwich to Birmingham and beyond, there was more opportunity for through trade, particularly from the Mersey.

Further trade links opened up by 1805, when the Ellesmere Canal linked to the Chester Canal at Hurleston Junction, which led to their merger in 1813 as the Ellesmere & Chester Canal. The extension to Birmingham was proposed in 1826, which encouraged the link to Middlewich and the Trent and Mersey to be attempted once more, this time successfully in 1833, fifty years after it was first mooted. Chester was finally linked to Birmingham in 1835, just in time for the arrival of the railways and another onset of 'mania'. Nevertheless, there would be some working together as the Shropshire Union Railways & Canal Co. was formed from

the Ellesmere & Chester Co. in 1846, which also took over a number of canals that joined theirs. It was leased to the London & North Western Railway the following year, which operated successfully until the decline in the first half of the twentieth century.

In Chester, the canal was constructed through the north side of the city where industry such as the lead works and the steam mill were attracted to its banks. Approaching the city walls, engineers took advantage of the remains of the defensive ditch and the dramatic cutting below the Northgate walls, before dropping the level 33 feet by way of a short flight of three locks (a fine example of a lock-keepers's cottage c. 1790 remains alongside, now Grade II listed). At the bottom a sharp right-angle turn opened out into the dock basin, where along the wharves there were offices, warehouses and a dry dock boat repair yard. Here at the roving bridge, the canal turned on a hairpin, and locks took it down directly to the River Dee.

On the wall of the roving bridge is a memorial plaque to engineer and author of several books on industrial history, L. T. C. 'Tom' Rolt. The greatest debt of thanks owed to this extraordinary man is the pioneering and determined work he carried out to ensure the declining, and in many places, derelict canal system be preserved for the country as a place of leisure. He was born in Chester where the former family home in Eaton Road, Handbridge, has a blue plaque to mark the event.

In his most famous book *Narrow Boat*, published in 1944, he documented a four-month trip in the working boat *Cressy*, which he converted into a liveaboard. He tells the story of how he fitted out the boat as a home and the journey of some 400 miles along the network of waterways in the Midlands, reflecting an age slowly disappearing. The book has since become a classic, and is credited with a revival of interest in the canal system, leading directly to the creation of the Inland Waterways Association, which became the driving force behind the restoration and leisure use of the canals.

On Tower Wharf there are surviving late eighteenth-century canal buildings. Telford's Warehouse is particularly impressive. Half over the canal, boats could enter below to be unloaded directly into the warehouse. Today it has been restored sympathetically as a pub/restaurant and local music venue. Adjacent is the L-shaped former Ellesmere Canal Company Offices and Tavern, where travellers on the packet boats from Liverpool made use of the facilities. The wharf complex has witnessed a great deal of regeneration in recent years, with modern housing lining the basin, while further development of residences and commercial premises line the lower basin towards the Dee.

Today the Shropshire Union Canal is a popular cruising and leisure waterway under the control of the Canal and River Trust, with attractive towpath walks through the city.

(For further reading and highly recommended - and not just for this topic - is the web site Chester Wiki (http://chester.shoutwiki.com) where there is excellent detail on local canal history.)

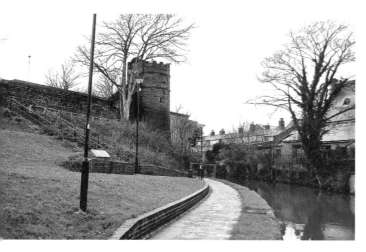

The canal curving past the King Charles I Tower (formerly the Phoenix Tower). (Photo: Lewis Royden)

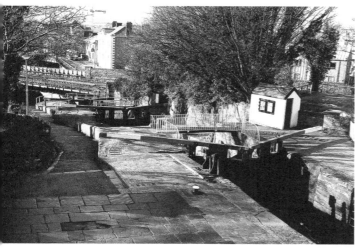

The lock flight. The white building in the distance is the former canal tavern, with Telford's Warehouse next door. (Photo: Lewis Royden)

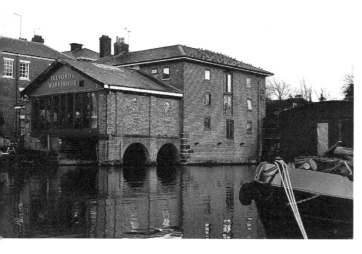

Telford's Warehouse. (Photo: Lewis Royden)

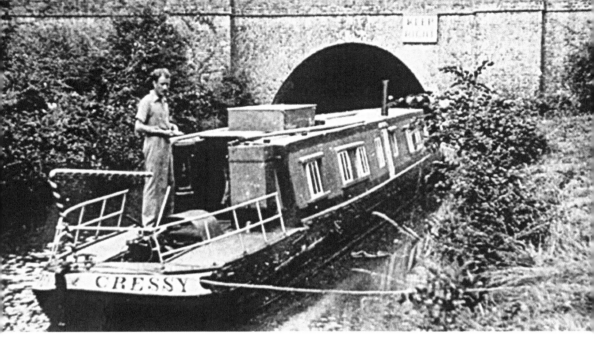

Above: Tom Rolt on board *Cressy*, made famous by his book *Narrow Boat*.

Below: Tom Rolt memorial plaque. (Photo: Lewis Royden)

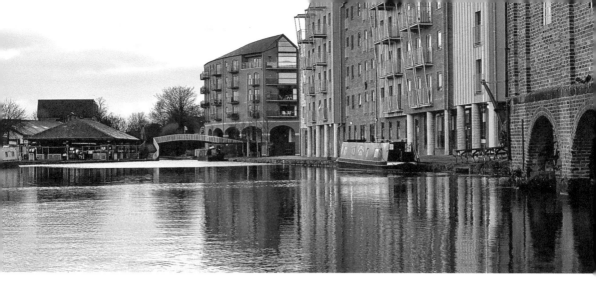

The regenerated canal basin – in the distance is Taylor's Boatyard and the Roving Bridge (Rolt's plaque is located on the wall on the base of the bridge partly hidden by the boat), while new residential blocks line the wharf with their mock-warehouse façade. The original arches of Telford's Warehouse complete the revitalised scene to the right. (Photo: Lewis Royden)

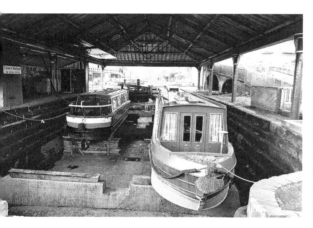

Taylor's Boatyard, thought to be one of the oldest complete working canal-side yards in the country, and possibly the best surviving example of a historic boatbuilding yard – parts of the yard date back to the 1840s. The yard takes its name from Joseph Harry Taylor, who took over the lease in 1921 when it was relinquished by the Shropshire Union Railway & Canal Co. In recent times it was run by David Jones for over thirty-five years until his retirement. (Photo: Lewis Royden)

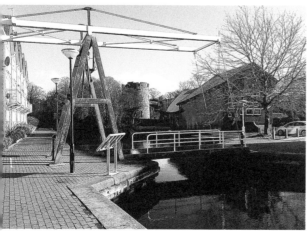

The regenerated lower basin with a new Dutch lift bridge and the Water Tower beyond. (Photo: Lewis Royden)

Siege of Chester

In this fatal battle fell many gentlemen of high rank, and officers of distinction; It is computed that not less than 600 men were killed on both sides, and many persons of quality of the King's party were taken prisoners. During the time of this fatal battle, his Majesty, attended by the mayor, Sir Francis Gamull, and Alderman Cowper, had the mortification of witnessing the rout of his army, from the leads of the Phoenix Tower, and also from the roof of the cathedral. The city was now deemed to be a place of very doubtful security to his Majesty; and on the following day, the royal fugitive took his departure, after giving orders to Lord Byron, the governor, and the commissioners, "that if, after ten days, they saw no reasonable prospect of relief, to treat for their own preservation."

Joseph Hemingway, *History of the City of Chester*, Vol I (1831), p.186

The king was Charles I, and the rout he observed from the Phoenix Tower at the north-eastern corner of the city walls was the Battle of Rowton Moor, a series of skirmishes across the fields to the east of Chester. The English Civil War, which was nearing its conclusion, had been raging since August 1642, and Chester as a Royalist stronghold was essential to maintain supplies and men from Ireland and North Wales.

However, by the autumn of 1644, the situation in the North West had become critical for the king as the Parliamentarian forces closed in. So far in Chester they were being held off behind the outworks – a defensive wall constructed by the digging of a ditch, piling the earth, and surmounting it with a wooden palisade, which ran from north-eastern end of the city wall to Barrell-Well Hill in Boughton, although it had originally encompassed most of the northern suburb.

Parliamentarian forces, led by Sir William Brereton, stormed Chester in February 1645 and attempted to scale the walls near the Northgate. The attack was repelled, but the siege intensified. In March, the king's nephew, Prince Maurice, arrived with a relief force, which brought some respite, but when he left just a month later, he took 1,200 Irish troops with him, leaving only 600 regular troops and a number of armed citizens to defend the city.

On 20 September 1645, the Parliamentarians made their move, and after a surprise attack at Boughton, the gates were opened and they poured into the eastern suburbs, the Royalists retreating just in time to close the Eastgate. Two days later, with a large number of cannon placed around St John's Abbey, they battered the walls to the south of Newgate, successfully breaching the wall. The attack was again repulsed as men tried to battle their way through the gap, with a number lost in the process.

The news soon reached the king in North Wales, who arrived with a relief force on 23 September, only to see the aforementioned rout at Rowton Moor. After his swift departure to Denbigh the following day, the Parliamentarians again breached the wall, this time on the north side near the Water Tower, but were again beaten back. This resulted in a change of tactics: they would just wait it out, while still bombarding the city from a safe distance.

Within the walls, the poor citizens were enduring intolerable conditions, with food supplies at an all-time low and many reduced to living on horses, dogs and cats, while a great many of their homes and business were seriously damaged. The Royalist leaders finally yielded on 3 February 1646, but their miseries were not yet over, as a dreadful disease broke out shortly afterwards and 2,000 inhabitants perished, the city becoming almost deserted.

In fact, it is estimated that a fifth of the population who had survived the siege were wiped out in the epidemic, and contemporary writers describe grass growing in the main streets, such was the neglect and condition of the city.

The effects of the war can still be viewed in several places on the walls, not least from the 'Roman Garden' where the repaired breach can be clearly traced. Gun ports for cannons are still visible on the north-western Spur Wall, while Morgan's Mount gun tower is also intact near Northgate (although it is likely there was originally a platform and defensive earthwork below the wall). The tower at the south-eastern corner is pockmarked with cannon ball marks, and the Phoenix Tower, on the north-eastern corner, now renamed King Charles I Tower, following its use as a royal observation point, hosts a small museum covering the conflict.

Numerous buildings have associations with the war, notably Mayor Thomas Cowper's home at No. 12 Bridge Street (his initials are still on the frontage), Sir Francis Gamul's house in Lower Bridge Street, where the king stayed, and God's Providence House in Watergate Street – so named as the original building was said to be the only house not touched by the plague of 1647.

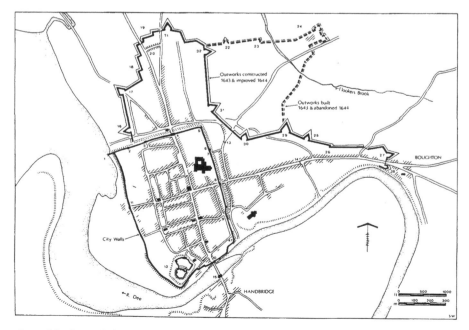

Plan of the later defensive outworks at the time of the siege.

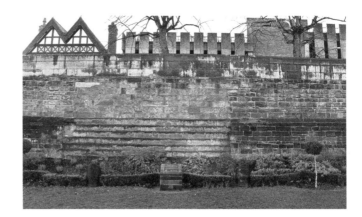

The site of the breach
on the City Walls,
just below Newgate.
(Photo: Lewis Royden)

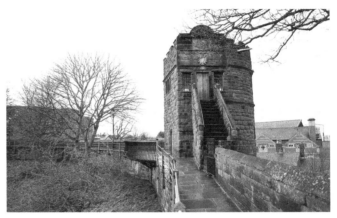

King Charles I Tower.
(Photo: Lewis Royden)

God's Providence House, Watergate Street Rows.
(Photo: Lewis Royden)

Tweddle, Beth, MBE – Britain's Greatest Ever Female Gymnast

When Elizabeth Kimberly Tweddle stood before the gathered throng of city dignitaries, academics and parents at Chester Cathedral in November 2013 to be awarded an Honorary Doctorate of Science, it was clear to all that this honour was a well-deserved recognition of the achievements and hard work, both physical and academic, that Beth has been committed to since a very young age. As she said in her acceptance speech,

> It's such an honour for me to be able to stand here today I grew up in this city, I was educated in this city and I just love coming back to Chester, so it is such an honour to receive this degree from the University of Chester. I felt throughout my gymnastics career that there was always one thing that was consistent, and that was my life here, whether it was the school that I attended and the supportive staff, or my family and friends who were always there for me.

Whereas some of those honoured in a similar fashion do not necessarily have ties with the city, in this case they were paying tribute to one of their own. Although Beth was born in Johannesburg, South Africa, on 1 April 1985, she moved with her parents Jerry, Anne and brother James to Bunbury in Cheshire when she was eighteen months old, and later attended the Queen's School in the city.

Today, Beth Tweddle is Britain's greatest ever female gymnast, and her list of achievements is quite remarkable. She is an Olympic bronze medallist, a triple world champion, a six-time European champion, a Commonwealth champion and seven-time consecutive national champion. However, this has come after years of dedication and hard work from the age of seven, plus support from her family and friends throughout her career. Coming from a sporting family where her older brother James was an England under-21 hockey player, Beth began training at local gym clubs before moving to the City of Liverpool Gymnastics Club to train with coach Amanda Reddin.

Her senior medal haul began in 2002 at the Commonwealth Games, when she won gold and two silvers. This began a string of exceptional performances that would result in over twenty more gold medals, competing all over the world in major championships and three Olympic Games – Athens 2004, Beijing 2008 and London 2012 – where she won Bronze in the uneven bars. Beth also carried the Olympic torch on the leg from Saltney into Chester, where she spoke excitedly to the cameras on her arrival, 'It's been really nice to bring it home, this is where I grew up, this is my home town, and I went to Queen's School just over the road!'

As if her sporting achievements were not enough, Beth also found time for her academic studies, graduating from Liverpool John Moores University with 2:1 in Sports Science in 2007. She then deferred a place at the University of Liverpool to compete in London 2012, then returned to complete a degree in Physiotherapy.

Further recognition for Beth came in 2010 when she was included in the Queen's New Year's Honours List, receiving an MBE for her success, commitment and dedication to gymnastics. Two years later, Liverpool John Moores University conferred upon Beth their highest honour when she was admitted as an honorary fellow of her former alma mater in 2012.

Since her retirement, she has been involved with Total Gymnastics with fellow Olympian, Liverpool swimmer Steve Parry, which they set up in 2009, with the aim of providing the opportunity for as many children as possible to take up gymnastics, within schools, leisure centres and gymnastics clubs, to help develop the sport around the country.

Tyler, Martin, Football Commentator

'A-guer-ooooowww...' he screamed, as the City striker made it 3-2 with virtually the last kick of the game. 'I swear you'll never see anything like this ever again. So watch it, drink it in ... two goals in added time from Manchester City to snatch the title away from Manchester United.'

It's right up there with Kenneth Wolstenholme's iconic words from 1966, but this was arguably the most dramatic moment in Premier League history, and Martin Tyler, one of the game's greatest commentators, called it to perfection.

Those memorable lines were uttered at the most improbable ending to a Premiership campaign yet witnessed, when Manchester City foiled their neighbours to win the trophy with the last kick, in the last minute, of the last game of the season. Manchester United's match had finished seconds earlier, and as they saw the score flashed up on the screen that City were 2-1 down, United were leaving the field, they believed, as champions; until two goals in injury time sealed it for the Sky Blues, and also for Martin Tyler. He was also now part of the folklore, with a commentary that will be repeated, no doubt for decades, over slow-motion replays of that final moment.

Martin Tyler was born in Chester on 14 September 1945, the son of Alan and Susan (née Jones) Tyler. His parents met while Alan, who was from Surrey, was serving with the Cheshire Regiment in the city during the Second World War, Susan's home town. They married after the war and moved to Alan's roots in the south when Martin was still an infant. His allegiance to Woking is well known to most football fans, but he has close ties to his birthplace, and while on trips to stay with his mother's family in Christleton and Tattenhall (where they owned the Aldersey Arms Hotel), he would go off on trips to watch Chester FC at Sealand Road, and he became hooked. He still has vivid memories of his first game as a thirteen year old on 27 December 1958, when on a chilly winter's afternoon he, along with 9,272 fans, watched Chester draw 0-0 with Millwall in a Fourth Division fixture. From that day on Chester has been close to his heart, and he frequently visited Sealand Road when he was in the city, especially during school holidays, and even driving up while at university in East Anglia.

His favourite season is still the 1964/65 campaign, with the 'Famous Five' strike-force, who scored an astonishing 138 goals between them, a golden period in Chester's history – he believes – that should never be forgotten. He has even completed a full collection of programmes from that historic season, both home and away – a compilation not finally collated in his teens, but in his sixties, reflecting his continued love of the club of his birthplace. As he told David Triggs of the *Chronicle* in 2010, 'We all look back on our childhood with huge nostalgia, and going to Sealand Road, that's what the club was for me. It was Chester FC, it was Sealand Road, it was blue and white stripes. My passport says 'born in Chester', and I'm proud of it.'

U

Undercrofts

An undercroft (sometimes incorrectly referred to as a crypt) is a cellar used for storage below buildings, often with medieval origins. Usually completely below ground, they were often brick-lined and vaulted, although many others had heavy timber ceilings. In Chester, where undercrofts were exceptionally numerous, they were partly above ground, thereby allowing street access. This enabled the development of the Rows above as houses became linked together (*see* Rows). As well as offering effective security, their cool temperature provided perfect storage for foodstuffs and wine, with the added benefit of a commercial frontage to the street above.

Around twenty medieval examples have survived from the thirteenth or early fourteenth century, some of which have vaulted ceilings. Many still have public access today, although usually as commercial premises. A fine example is found at No. 12 Bridge Street (also known as Cowper's House after Thomas Cowper, the mayor during the Civil War), with an undercroft of six bays with plain rib vaulting, which for many years housed a bookshop.

On the opposite side of the street at No. 15 Bridge Street is an undercroft with two double-chamfered arches, while further down on the corner of Lower Bridge Street is the The Falcon Inn, which has an undercroft formerly of three bays, but which has now been divided into two chambers. At No. 28 Eastgate Street (Brown's Crypt Chambers), a pleasant experience can be had, while taking in the ambience of the four-bay undercroft, in enjoying refreshment in the restaurant below street level.

In Watergate Street there are several fine examples. No. 21/23 ('Corks Out' wine specialists bar) has a quadripartite vault of 3 bays with chamfered ribs on moulded corbels, with half of the front bay removed to accommodate a deep stone-cut cellar and a self-contained shop.

No. 37 Watergate Street, sometimes referred to as St Ursula's due to its past use as café of that name, and currently in use as a storeroom for the neighbouring toy shop, is of such high quality that it has been listed as Grade I by Historic England. The undercroft has five and a half bays, and it is considered that the rear door arch and walls possibly date from the late twelfth century, and are potentially the earliest features yet to have been dated in the structure of Chester Rows undercrofts.

However, for the visitor, it is No. 11 Watergate Street (occupied by 'The Watergates Bar'), with its four bays of quadripartite vaulting, divided by an arcade of three octagonal piers, that gives a view of possibly the best stone undercroft in the city currently accessible to the public.

Undercroft below No. 12 Bridge Street in 1849 after rubble had been cleared (drawn by J. Romney *c.* 1855). Until recently it was the fondly remembered Booklands.

No. 37 Watergate Street, the former St Ursula's tearoom. (Photo: Lewis Royden)

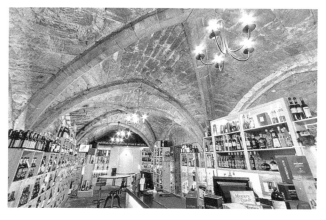

Corks Out wine specialists bar, No. 21/23 Watergate Street, impressively restored and stocked.

V

Victoria Jubilee Eastgate Clock

The present gateway in the main thoroughfare of Eastgate dates from 1768, but stands on the site of the original Roman gate to the fortress of Deva Victrix. However, the eye is immediately drawn to the clock surmounting the gate, which not only dominates the surroundings it surveys, but the popular images too of the city, to an extent that it is believed to be the most photographed clock in the country after the Big Ben clock on the Elizabeth tower. The Eastgate clock is clearly of a later date than the gate and was built to a design of John Douglas in 1899.

Local architect John Douglas (see John Douglas) was asked by Hugh Grosvenor (3rd Marquess of Westminster) as early as 1872 to submit a number of designs for a proposed improvement of the Eastgate. The scheme came to nothing, but was revived in 1896 to celebrate the diamond jubilee of Queen Victoria. A committee was set up to assess the various proposals, and a final decision was made to erect a memorial tower and clock on the gate. John Douglas was again invited to submit appropriate designs, the first of which was a stone structure, but was rejected as it would block out too much light to the neighbouring properties on the narrow street below. The committee were more in favour of a clock set within a light iron structure, and requested Douglas submit a new design, which was approved in March 1898.

The tower was funded by public conscription, while the clock and the mechanism was paid for by local solicitor Edward Evans-Lloyd. The reputable clock-making firm of J. B. Joyce & Co. of Whitchurch, Shropshire – thought to be the oldest in the world – were contracted to make the four-sided clock and mechanism. (The firm made large clocks for many public buildings, both at home and overseas, and for some of the principal railway companies, including the large clock in Liverpool Lime Street Station. Their former company building in Whitchurch continues in use as the auction house for Trevanion & Dean – Christina Trevanion being well known for her appearances on TV antiques programmes). J. B. Joyce continued to maintain the clock and regularly despatched a technician to keep it wound up. The original mechanical system was replaced by an electrical mechanism in 1992.

The Coalbrookdale Iron Co. made the cast=iron inscriptions, while John Douglas commissioned his cousin's firm, James Swindley of Handbridge, to construct the

tower ironwork, topped by a copper ogee cupola. This in turn is surmounted by a weather vane with the heraldic image of 'lions rampant or on gules background' (i.e. lion on hind legs, with forepaws raised, on gold and red tinctured background). The clock was officially opened on 27 May 1899, timed to coincide with Queen Victoria's eightieth birthday.

Its architectural importance and value to the city of Chester was acknowledged on 28 July 1955 when the clock and gateway were designated as a Grade I-listed building. In 1988, the hands of the clock were stolen, resulting in the installation of a protective glazing, while renovation work on the clock faces in 1996 restored their original colour.

Today, the clock is a ubiquitous image and can be seen everywhere around the city from taxi licence plates, guidebooks and postcards to countless souvenirs. It has become an iconic image synonymous with the city, making it instantly recognisable. It is ironic that John Douglas who designed so many fine buildings in a variety of pioneering styles should be most remembered for a clock. However, this is no ordinary clock, and is a fitting memorial to his work considering it difficult to find a suitable acknowledgement elsewhere.

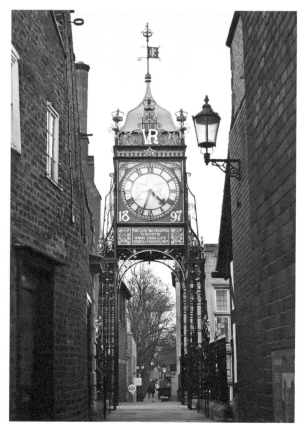

The Victorian Eastgate Clock viewed from the City Walls. (Photo: Lewis Royden)

Walls

The famous walls today are often referred to as the 'Roman Walls' but this is incorrect. Certainly, they are partly of Roman foundation, and sections of stonework can still be seen today, but there have been numerous rebuilds over the centuries, as well as extensions deviating far from the original Roman layout. None of the Roman gateways or towers survive, and all four main gates date from the eighteenth and nineteenth centuries (*see* Northgate Goal, Victorian Clock, Eastgate).

The Roman construction began between AD 70 and 80 to defend their fortress of Deva Victrix, and consisted initially of a temporary earthen rampart formed from the digging of a defensive V-shaped ditch, the wall surmounted by a wooden palisade. This was gradually replaced with sandstone over the next century by the occupying Legio XX Valeria Victrix (*see* XX Legio Valeria Victrix). Defensive wooden towers were constructed along the course, along with those at the main gates on each of the four sides, the present Northgate and Eastgate standing on their original sites. The Northgate was likely to have had a single arch, while the others had twin portals. The main approach was the Eastgate, and was therefore particularly impressive, possibly consisting of three storeys.

After major repairs during the fourth century, little is known about the wall until Chester was refounded as a Saxon burgh by Æthelflæd in 907, when some improvements were made. After the Norman Conquest, the Roman defences were extended by the mid-twelfth century south and west towards the river, to provide a complete defence of the developing medieval town, while also enveloping the new motte-and-bailey castle constructed under the orders of William the Conqueror.

This led to the construction of three new main gates: the Watergate, giving access to the river on the west side, the Shipgate and the Bridgegate giving similar access to the south. The present route around the walls follows this medieval circuit.

By the seventeenth century the walls were in a poor state, with several crumbling gaps along its course. However, with the onset of the Civil War in the 1640s, there were hurried repairs and improvements, plus the construction in the suburbs of a temporary outlying advanced wall of turf ramparts, now long removed. Damage to the main wall was extensive, especially following the Parliamentarian siege, which also resulted in two major breaches.

As a defensive structure, the walls had outlived their purpose by the early eighteenth century, and for the first time moves were made by the City Assembly to revive them purely for aesthetic purposes. Plans were drawn up to utilise them as a historic promenade, with places to stop and enjoy the view. Consequently, this was the catalyst for more extensive alterations and resulted in the construction of new gateways with wider passages both above and below – Eastgate being replaced in 1768, Bridgegate in 1781, and Watergate in 1788. Northgate was more complicated, as it also required the removal of the integral goal, but this was achieved by 1810 (*see* Northgate Gaol). Unfortunately, the new gaol necessitated a complete breach in the medieval wall and the removal of the Shipgate, but the arch can still be seen today having been relocated to the Grosvenor Park.

Other improvements for walker's access were carried out during the eighteenth and nineteenth century, including the Recorder's Steps on the southern riverside section in 1720. This certainly brought a great influx into the city, as tourism became more popular, benefiting too from away-day journeys with the arrival of the railways in the mid-nineteenth century.

Modern road traffic requirements have seen two major twentieth-century breaches in the fabric of the wall. In 1938, the Grade II-listed Newgate was erected over Pepper Street, facing the amphitheatre, to alleviate congestion mainly around the Eastgate to Chester Cross area. This was followed by further road improvements in the 1960s, when the construction of the new inner ring road necessitated a section of the north wall removed to accommodate a new linking bridge over the dual carriageway. Functional and utilitarian, in concrete and disappointingly bland, St Martin's Bridge opened in 1966. Given the efforts to assimilate the surrounding modern housing into the historical landscape, it looks even more out of place today, and will no doubt remain as the only gate without listed status.

Today, the walls are now a major tourist attraction, visitors being able to walk a complete circuit of the near complete 1.8-mile medieval route (2.95 km). All manner of guides are available, from the city tour guides and re-enactments to booklets, websites, and on-location smartphone hotspots. (See, for example, Steve Howe's excellent *Chester: A Virtual Stroll Around the Walls* at www.chesterwalls.info.)

There has been a continued debate and argument as to whether the Eastgate originally had two arches. This depiction shows what was believed to have been the original Roman gate, revealed when the medieval gate was being stripped back and dismantled in 1768.

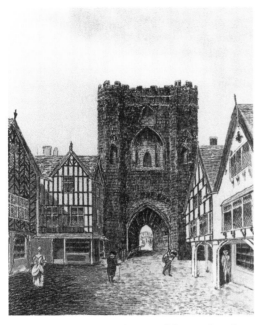 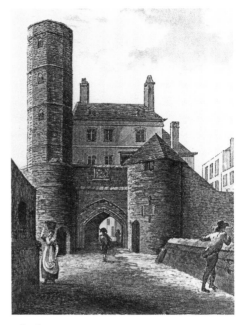

Above left: Conjectural view of the medieval Eastgate before 1768.

Above Right: The Old Bridgegate, taken down in 1781.

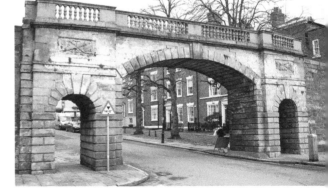

The Georgian Bridgegate. (Photo: Lewis Royden)

Pemberton's Parlour, a medieval watchtower, known as Dille's Tower in the reign of Henry VIII, later known as Goblin Tower. After reconstruction in the early eighteenth century it was used by John Pemberton, a ropemaker, to keep watch over his men working below. After a collapse in 1893, it was rebuilt the following year. (Photo: Lewis Royden)

XX Legio Valeria Victrix

Caecilius Avitus probably always had intentions of being a career soldier. He was brought up in a military family in Lusitania, where his family had settled in the capital Emerita Augusta (present-day Mérida, Spain). The colony had been founded in 25 BC by Augustus to resettle soldiers of rank who had been discharged or retired from the Roman army from two veteran legions of the Cantabrian Wars. When he signed up for the Roman army he ended up in Britain in the 20th Legion, which occupied the fort at Deva. He married, had a family, but after fifteen years' service, Caecilius Avitus died aged only thirty-four. His son and heir, proud of his father's achievements, arranged for a memorial tombstone to be placed into the wall of the fort near the Northgate. It was an elaborate sculpture, showing his bearded likeness with an inscription. He stands holding a staff in his right hand, while his left hand grasps the handle of a square tablet case. The inner faces of this were coated with wax upon which administrative work was inscribed with a stylus. The tablets were then folded, tied, sealed and dispatched. His head is bare and wears over the tunic a heavy cloak *(sagum)*, of which the ends cross and hang down his front in two tails. A sword, with massive round pommel, hangs on his right side. Below the cloak, a kilt reaches to the knees. By the time of his death he had reached the rank of *optio*, roughly equivalent to that of a modern first sergeant, with a status as the second in command of the century.

The Grosvenor Museum has an excellent collection of Roman artefacts, not least in the gallery of memorials and inscriptions, where the tombstone of Caecilius Avitus, discovered in 1891, can be viewed today. The inscription survives and reads,

D(is) M(anibus) / Caecilius Avit / us Emer(ita) Aug(usta) / optio leg(ionis) XX / V(aleriae) V(ictricis) st(i)p(endiorum) XV uix(it) / an(nos) XXXIIII / h(eres) f(aciendum) c(uravit)

To the spirits of the departed, Caecilius Avitus from Emerita Augusta, optio of the 20th legion Valeria Victrix, of 15 years' service, lived 34 years. His heir had this erected.

The opening story may be conjectural in places, but Caecilius Avitus was part of the occupying force at Chester. Precisely when he was here is less certain.

Legio vigesima Valeria Victrix (the Twentieth Victorious Valeria Legion), with whom he served, was one of the four with which Claudius invaded Britain in AD 43, and after various campaigns in the conquest they came to Deva Victrix (Chester) in AD 88, a fortress founded by the Legio II Adiutrix in the AD 70s. It was rebuilt by the Legio XX Valeria Victrix over the next few decades, and would remain as their operating base for the next two centuries, during which time they were involved with the construction of Hadrian's Wall, and possibly the Antonine Wall. The legion was known to be still active in the late third century, but little is known after that time, although some historians believe they were still stationed in Britain during the final withdrawl of Roman forces in the early fifth century.

Right: Tombstone of Caecilius Avitus (held in the Grosvenor Museum, Chester).

Below left: Conjectural model of the Chester Roman fort and settlement (held in the Grosvenor Museum, Chester). (Photo: Lewis Royden)

Below right: A moulded antefix roof tile showing the emperor's image and the charging boar, the badge of the 20th Legion (held in the Grosvenor Museum, Chester).

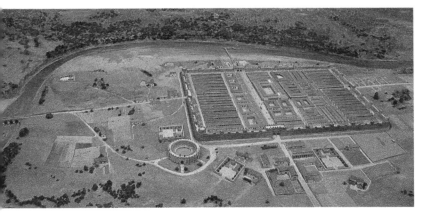

Yacht Inn Tragedy

Approaching ten in the evening on Friday 6 June 1879, it was another quiet night in the Yacht Inn. So much so that publican Daniel Miller had joined his regular customer Tom Aspey for a beer at his table in the bar. In the lobby, old Mr Eaton was selling pots of hot peas as usual by the door, while the piano player had just rattled out another tune on the upright. Daniel began wondering if he had made the right decision to give up coopering and step up to running his own place, after moving to Chester nine months earlier from London. His mother's sister Eliza ran the Ship Inn in Handbridge with husband Alex, and had let him know the licence for the Yacht was available. It was supposed to be a fresh start after losing his young twenty-two-year-old second wife Emily after just a few months of marriage in 1874.

He hoped he'd found happiness again after marrying Martha the following year, but she hadn't been well since the move to Chester, her health was delicate and she seemed very depressed since Lizzie's birth, more so in the last two weeks. (Martha had also been coughing up blood, a sign of consumption. No doubt today, she would have been treated for tuberculosis as well as post-natal depression.)

The trouble last month when his waiter John Badger turfed out the two buskers for insulting his piano player hadn't helped matters, especially when he ended up in court. The two musicians, a Liverpool lad and an Irish girl with a fiddle, had stopped by to ask if they could play as they were short of money. Then the maid, the Welsh girl Mary Ann, just upped and left for home before anyone was up on Monday. Times were tough.

That night Martha had retired to bed as usual at eight, with little Alice aged two and baby Elizabeth Mary – or Lizzie May as he was wont to call her. (Daniel also had four children from his first wife: Mary Jane, seventeen, Lydia, fifteen, who were now in service, Emma, ten, and young George, still at home.)

Suddenly he was jolted from his thoughts by Emma shouting through the door to come quickly, as she had heard dreadful screams coming from the bedroom. He raced up the stairs with Aspey in tow, and had to kick the locked door open. Bursting inside, he was greeted with a scene of horror; there was blood everywhere. Martha was sat on the bed, wide-eyed staring wildly, grasping her neck, where he could see

a deep wound oozing blood. Next to her on the bed lay Lizzie May, her throat cut, and his eyes quickly went to the cot. He rushed forward and grabbed the infant in her blood-soaked nightgown, her throat sliced too, and he cradled her as her arms flopped down. Aspey saw what looked like an ordinary kitchen table knife stained with blood on the floor by the bed as he held on to Martha's wrists, before Daniel pleaded with him to fetch a doctor.

Once the help arrived, Martha was moved to the front bedroom to allow the police officers to study the crime scene, before a distraught Aunt Eliza arrived after young George had rushed to the Ship to fetch her. Dr Hamilton stitched the baby's throat and dressed the wound, while Surgeon Harrison tried to do the same to Martha, but she was having none of it, and began tearing at her throat. She became so violent that they had to send out to the infirmary for a straitjacket to restrain her.

Martha was put to bed, while Eliza sat with her through the night and into Saturday. During the day Martha began to ramble: 'Bronchitis, measles, and whooping cough, and now they say I'm in a decline. We will all four go together.' Eliza asked her what she meant, but she just stared and didn't recognise her. She continued to babble similar nonsense throughout the day, and had no recollection of the events of the previous evening.

Attempts to save baby Alice had been in vain, the shock to her little body had been too great, she had lost too much blood, and she died in her cot on Sunday morning.

The following day, the coroner began the inquest on Alice in the Town Hall, and the jury filed into the bedroom at the Yacht to see her lifeless form, before returning to the court where they took only forty minutes to return their verdict; Martha was charged with wilful murder.

However, before the warrant could be issued, she had been removed from the Yacht Inn to the Chester Asylum in Upton, while Lizzie May was taken to the infirmary on the same day.

For poor Daniel there was little time to grieve. No sooner had the proceedings of the inquest concluded than he was summonsed to appear before the Board of Guardians, who wanted to be reimbursed in full for the expenses already incurred for Martha's care in the asylum, and to set a rate for her future care.

Martha was too unwell to face charges and remained in the asylum. However, just a few months later there was a final twist when on 6 October she gave birth prematurely to a baby girl. The whole ordeal was just too much for Martha, and she passed away three days later on 9 October 1879 aged only thirty. To recall Martha's rambling words to Aunt Eliza: is this what she really meant by 'We will all four go together'?

The newborn infant was taken to the Yacht Inn and given to her father, although the dreadful events of that year had yet to end for Daniel, as she was to live for just a few short weeks.

By 1881 Daniel was still landlord of the Yacht Inn, where his children also lived, including young Lizzie May, who had survived her injuries. As Daniel tried to rebuild

his life, he married again for the fourth time, to Catherine Fletcher in Chester on 22 May 1882 when he was forty-three years old.

Within two years Daniel Miller had decided to seek yet another fresh start, but in this case on the other side of the world in Australia, and he would take all his children with him. His new wife Catherine did not join him. Maybe she was too ill and hoped to follow, but she passed away in Chester in July 1888, aged fifty-four.

Daniel's move to Queensland seems to have been successful. His children married, had their own families and their descendants still live in Australia today. After almost three decades in Australia, Daniel Miller passed away on 1 January 1913 in Rosalie, Queensland, at the age of seventy-three.

Today, no sign of the Yacht Inn remains, having been demolished in 1965 to make way for the new St Martin's Way inner ring road, although it is said the foundations and cellars still exist beneath the left-hand carriageway.

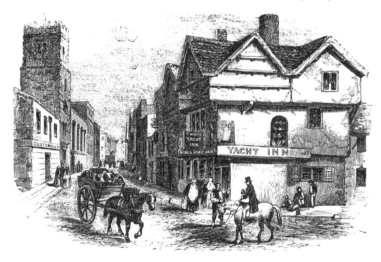

The Yacht Inn, drawn for Thomas Hughes' *The Stranger's Handbook to Chester* (1856).

SHOCKING TRAGEDY AT CHESTER.

The Yacht Inn, Watergate-street, which Dean Swift has immortalised in connection with a visit of his to Chester, was on Friday evening, the 6th inst., the scene of an incident of absorbing interest which developed into the serious proportion of a tragedy fortunately of very rare occurrence in this city. The present and but recent occupant of the house is a man named Miller, who married his third wife about four years ago, having living four children by his previous marriages. For some months past Mrs. Martha Miller, who is thirty years of age, has been in delicate health, and during the

News headline and article extract from the *Cheshire Observer*, 14 June 1879.

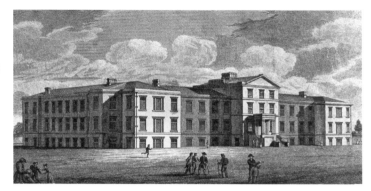

The Cheshire Lunatic Asylum, Upton. The old mental hospital building is now called the 1829 Building and serves as headquarters for West Cheshire CCG, Cheshire and Wirral Partnership NHS Foundation Trust and various NHS support organisations.

The Yacht Inn on the corner of Watergate Street and Nicholas Street in the late 1890s/ early 1900s.

Street entertainers at the Chester Cross, Eastgate. The buskers may have been thrown out of The Yacht Inn, but today the city is known for its high-quality street entertainers. (Photo: Lewis Royden)

Zoo – Chester Zoo with a Secret Life

Chester Zoo, which is located in Upton-by-Chester, is one of the country's largest zoos. It covers 125 acres, although its land ownership extends to around 400 acres. There are currently over 9,000 animals out of a total range of over 700 species. Most zoos are established by zoological societies or from the collections of wealthy nineteenth-century owners, but here we have an exception.

Chester Zoo was the brainchild of George Mottershead, who was born in Lindow Terrace (now Lindow Street), Sale, on 12 June 1894, to parents Lucy and Albert, a botanist and nurseryman. As a youth, he had aviaries, with tanks for pet lizards and snakes, but by sixteen he had left home to become a fitness instructor, running a bodybuilding gym.

When the First World War broke out, George served with the South Lancashire Regiment, but was badly injured after being shot in the neck in the Battle of the Somme in October 1916. Doctors feared he would never walk again, but after three years in a wheelchair he was back on his feet, albeit with a limp.

While on leave in 1916, he married Elizabeth Atkinson, and their daughter Muriel was born in 1917, followed by June in 1926. After a move to Shavington in the 1920s, he established a successful market garden and opened a shop selling home-bred exotic birds and vegetables grown by his father. When recession struck, he converted his father's allotment into a miniature zoo, determined to follow his childhood dream (as a youngster he had been taken for a visit to Belle Vue Zoo in Manchester, where he became upset about the animal's welfare, telling his father that if he had a zoo it would be without bars). Looking to expand and move away from unsympathetic neighbours, with help from his father-in-law, he completed the purchase of Oakfield Hall and its 9-acre estate, (formerly in the hands of Benjamin Chafers Roberts, a wealthy tea merchant and Lord Mayor of Chester, who died in 1923).

Despite initial local objections and a public inquiry, the Ministry of Health granted them a licence in April 1931, and the zoo opened on 10 June that year. Inevitably, those first years were a real struggle to become established, while the family worked around the clock, all sharing the jobs between them. George was director-secretary, wife Lizzie dealt with the catering, and Muriel, their daughter, was the zoo's first curator.

June was still too young, but as soon as she was old enough, she joined in with the rest of the family in helping wherever she could. George's parents, now in their seventies, were also completely involved. Albert took charge of the greenhouses and gardens as he had a horticultural background, while Lucy, George's mother, staffed the zoo's first entrance and pay booth, which was little more than a wooden shed. When the zoo first opened, there were so few visitors that they would have to ring a bell to summon Lucy from the lodge to take their money –1s for adults and 6d for children.

Within three years matters came to a head as the zoo was in danger of being closed down. George Mottershead decided to turn the zoo into a society and be run as a non-profit organisation. An appeal was made for financial backing, and on 9 May 1934 the North of England Zoological Society was created, with a council of elected members formed to help advise and guide the zoo in the right direction for the future.

They even succeeded in keeping the zoo thriving during the war years, and they were constantly receiving animals from around the country for safe keeping, including its first pair of elephants from a circus in 1941. Their belief and determination paid off, as by the 1950s the annual visitor numbers were up to half a million.

Lizzie, so often the voice of reason while supporting George's dreams, passed away in 1969 after working in the zoo for four decades. George Mottershead's achievements with the support of his family earned him an OBE, as well as an honorary Master of Science degree, and a term as president of the International Union of Zoo Directors. By the time of his death in 1978, at the age of eighty-four, George's dream of a 'zoo without bars' was well and truly thriving at Chester.

Today the zoo is the most popular in the country and there are now 170 buildings, from the animal exhibits to the shops, restaurants, and admin offices. Plus, of course, the original Oakfield House itself and stable block, which are both Grade II listed. It is the most-visited wildlife attraction in Britain, with more than 1.4 million visitors annually.

Behind the scenes, life at the zoo has been a feature of the TV documentary series *Zoo Day* commencing in 2007, followed by the series *The Secret Life of the Zoo* from 2016. In 2014, the BBC broadcast the drama *Our Zoo*, telling the story of the 1930s founding of Chester Zoo by the Mottersheads, based on the memoir by daughter June (Mottershead) Williams. Sadly, June passed away in her home in Upton, close by the zoo in 2015, aged eighty-eight.

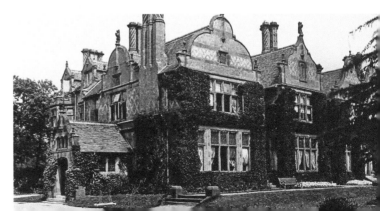

Oakfield Hall.

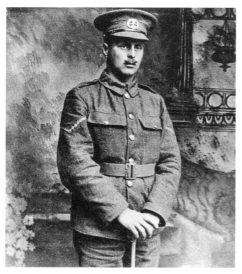

Above left: George Mottershead.

Above right: Chester Zoo in 1962.

Materials were in short supply just after the war when construction of the bear enclosures commenced. George Mottershead instead acquired some of the obsolete anti-tank roadblocks within a 10-mile radius (over 2,000), plus the pillboxes located around the zoo. This photo shows the original enclosure in 1962. Polar bears are no longer kept at the zoo, but some of the structure is still visible in the zoo today.

Further Reading

Newspapers
Chester Observer
Chester Chronicle
Chester Courant

Books
Carrington, Peter, *Chester* (English Heritage, 1994)
Hartwell, Clare; Hyde, Matthew; Pevsner, Nikolaus, *Cheshire: The Buildings of England* (Pevsner Architectural Guides: Buildings of England) (2011)
Hurley, Paul & Morgan, Les, *Chester Through Time* (2010)
Hurley, Paul, *Chester History Tour* (2016)
Hurley, Paul, *Chester in 50 Buildings* (2017)
Jones, Philip, *Building Chester* (2010)
Langtree, Stephen & Comyns, Alan, Ed., *2000 years of building: Chester's Architectural Legacy* (2001)
Lewis C. P. & Thacker, A. T. eds., *A History of the County of Chester, vol. 5, part 1, The City of Chester: General History and Topography* (London, 2003)
Lewis C. P. & Thacker, A. T. eds., *A History of the County of Chester, vol. 5, part 2, The City of Chester: Culture, Buildings, Institutions* (London, 2005)
Morris, Richard, Hoverd, K, *The Buildings of Chester* (1993)
Pevsner, N. & Hubbard, E., *The Buildings of England: Cheshire* (1971)
Ward, Simon, *Chester: A History* (Paperback)

Early Guides
Broster, John, A Walk Round the Walls and City of Chester (1821)
Hanshall, J. H., *A History of the County Palatine of Chester* (1823)
Hemingway, Joseph, *History of the City of Chester*, Vol I & 2 (1831)
Hughes, Thomas, *The Stranger's Handbook to Chester* (1856)
Pennant, Thomas, *A Tour in North Wales 1773* (1778)
Pigot, I. M. B., *History of the City of Chester* (Chester, 1815)
Windle, B., *Chester, A Historical and Topographical Account of the City* (1904)

Online
National Heritage List for England (Scheduled Monuments List)
 www.historicengland.org.uk
National Record of the Historic Environment (NRHE) (Historic England)
 www.pastscape.org.uk

Revealing Cheshire's Past (Cheshire Historic Environment Record)
 http://rcp.cheshire.gov.uk
British History Online – www.british-history.ac.uk/vch/ches/
BBC– *Desert Island Discs*: Duke of Westminster (1995)
https://soundcloud.com/desert-island-discs-99/dida-duke-of-westminster

Finally, two excellent websites on Chester's history are highly recommended, which also accept contributions:
Elliot, Peter, Chester Wiki – http://chester.shoutwiki.com
Howe, Steve, *Chester: A Virtual Stroll Around the Walls* – *www.chesterwalls.info*

The author and publisher would like to thank the following people/organisations for permission to use copyright material in this book:
Peter Boughton FSA, Keeper of Art, Grosvenor Museum, Chester (Charles Kingsley portrait)
Cheshire West and Chester Council (Bridge of Sighs image)
Chester Cathedral (Images of Thomas Brassey bust)
Grosvenor Museum, Chester (Roman gallery images)
Every attempt has been made to seek permission for copyright material used in this book. However, if we have inadvertently used copyright material without permission/acknowledgement we apologise and we will make the necessary correction at the first opportunity.

About the Author

Mike Royden has taught history for over thirty years, and has also lectured on numerous courses in local history in the Centre for Continuing Education at the University of Liverpool. He has researched and written about various aspects of history for over thirty-five years. He has written several books, including the popular *Tracing Your Liverpool Ancestors* and *Liverpool Then and Now*, both of which are now in a second edition. He has made regular appearances on radio and television including Radio 4's *Making History* and BBC's *Heirhunters*, as well as filming with Hollywood star Kim Cattrall, discussing her Liverpool roots for *Who Do You Think You Are?* He also appeared on the programme featuring Gareth Malone in the same series, and contributed research to the Sir Ian McKellen episode. Mike also appeared with Ricky Tomlinson in the *Blitz Cities* series on Liverpool during the Second World War. He has also researched extensively into the history of the First World War and has led tours on the Battlefields of France and Flanders. In 2017, he was elected as a member of Everton FC Heritage Society. Mike Royden also runs several history websites at www.roydenhistory.co.uk.

He has two sons, Lewis, who is a photographer, and Liam, a musician.

Other titles by Mike Royden:

Merseyside at War 1939-45 (2018)
Tales from the 'Pool: A Collection of Liverpool Stories (2017)
Village at War: A Cheshire Village During the First World War (2016)
Liverpool Then and Now (2012, 2nd Edition 2015)
Tracing Your Liverpool Ancestors (2010, 2nd edition 2014)
Did Adolf Hitler visit Liverpool in 1912/13? - BBC.co.uk website (Legacies)
A History of Liverpool Maternity Hospital and the Women's Hospital (1995)
A History of Mill Road Hospital, Liverpool (1993)
Pioneers and Perseverance: A History of the Royal School for the Blind, Liverpool, 1791-1991 (1991)

Forthcoming titles:

Wirral at War (Amberley, 2018)
Chester at War (Amberley, 2019)
Sails, Shipwrecks and Suffragettes: A History of Thomas Royden & Sons, Liverpool, Shipbuilders (due 2018)

Acknowledgements

Nick Grant at Amberley.

Peter Boughton FSA, Keeper of Art Grosvenor Museum, Chester.

Cheshire Record Office.

Lewis's Café, Farndon (Alison, Nicky, Nikki, and Jen for keeping me supplied throughout).

Liam for all the support and Lewis for all the help with photographs and illustrations

All modern photographs by Lewis Royden unless indicated (Lewis Royden Photography, www.lewisroyden.co.uk).